Photoshop Effects for Portrait Photographers

D0224910

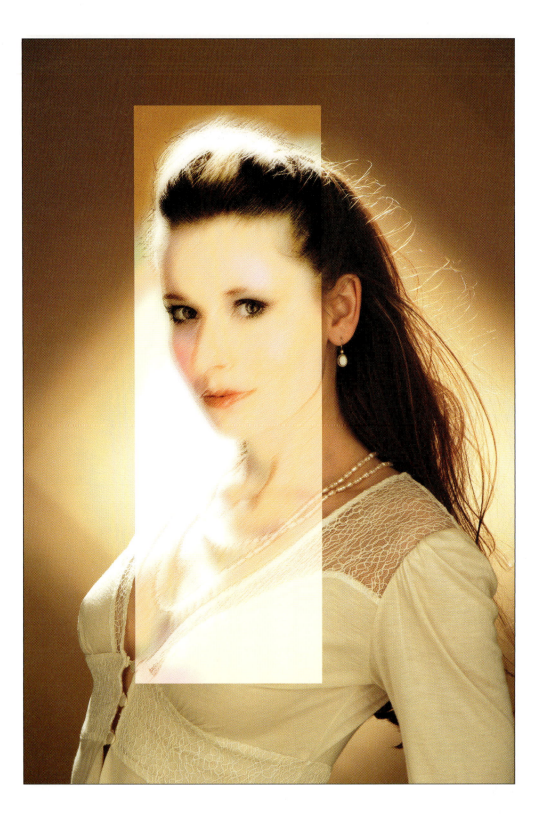

Photoshop Effects for Portrait Photographers

Christopher Grey

AMSTERDAM • BOSTON • HEIDELBERG • LONDON • NEW YORK • OXFORD
PARIS • SAN DIEGO • SAN FRANCISCO • SINGAPORE • SYDNEY • TOKYO

Focal Press is an imprint of Elsevier

Acquisitions Editor: Diane Heppner
Project Manager: Paul Gottehrer
Assistant Editor: Stephanie Barrett
Marketing Manager: Christine Degon Veroulis
Cover Design: Eric DeCicco

Focal Press is an imprint of Elsevier
30 Corporate Drive, Suite 400, Burlington, MA 01803, USA
Linacre House, Jordan Hill, Oxford OX2 8DP, UK

Copyright © 2007, Elsevier Inc. All rights reserved.

No part of this publication may be reproduced, stored in a retrieval system, or transmitted in any form or by any means, electronic, mechanical, photocopying, recording, or otherwise, without the prior written permission of the publisher.

Permissions may be sought directly from Elsevier's Science & Technology Rights Department in Oxford, UK: phone: (+44) 1865 843830, fax: (144) 1865 853333, E-mail: permissions@elsevier.com. You may also complete your request on-line via the Elsevier homepage (http://elsevier.com), by selecting "Support & Contact" then "Copyright and Permission" and then "Obtaining Permissions."

∞ Recognizing the importance of preserving what has been written, Elsevier prints its books on acid-free paper whenever possible.

Library of Congress Cataloging-in-Publication Data
Application submitted

British Library Cataloguing-in-Publication Data
A catalogue record for this book is available from the British Library.

ISBN 13:978-0-240-80894-9
ISBN 10:0-240-80894-0

For information on all Focal Press publications
visit our website at: www.books.elsevier.com

06 07 08 09 10 10 9 8 7 6 5 4 3 2 1

Printed in Canada

Working together to grow
libraries in developing countries

www.elsevier.com | www.bookaid.org | www.sabre.org

ELSEVIER BOOK AID International Sabre Foundation

Contents

Section 3

Foreword

As a professional photographer, I consider myself lucky to be so totally immersed in this evolutionary step of digital photography. I began working with Photoshop at version 2.5, and as the program got better and computers got faster, Photoshop time overtook darkroom time. My computer officially became my darkroom in 2001.

Still, there were aspects of the "old days" that I missed. For instance, I enjoyed vignetting portraits by hand, in the darkroom. I always felt my organic vignettes added a degree of charm to the images that they wouldn't have otherwise had.

Kodak makes terrific black and white infrared film, but best results with it are obtained by hand processing in the darkroom, something I now have little time to do.

Some equipment, like view cameras, yield spectacular images when the swings and tilts are placed where they shouldn't be, but are slow and cumbersome, and not really suited to the style of photography that I like.

It was the search for intelligent solutions to these and other questions that led me to this book. When I approached Photoshop analytically, instead of as a complex retouching tool, I began to learn how to enhance images in new ways. Over time, I not only found elegant solutions for my analog photography questions but for illustrative and painterly techniques as well.

The best thing to come from my research was something I hadn't counted on; my clients were as excited about seeing themselves interpreted by my tricks as I was when I did them. Even better, they were willing to pay more than normal price to own reprints.

All the techniques you'll learn in this book are doable with just the basic controls and filters that come with the program. Whether you use them to have fun, for art, or to increase your studio's bottom line, I know you'll enjoy them.

Christopher Grey

Introduction

Over the time I needed to write this book, it became obvious I had to make a few assumptions about my audience. My first (and most necessary) assumption is that you are at least familiar with Photoshop on an intermediate level, that you understand the concept of Layers and Blending Modes and that you are willing to spend some time to learn a new way of thinking. If you're new to Photoshop, there's no reason why you can't use my tricks, but any introductory instruction you might need will have to be found elsewhere.

Even though these effects were built with Photoshop CS2, they will (almost) all work with any version of PS that supports Layers. Within the entire book, I believe I've used only two filters that are new to CS2, but those are largely optional steps, anyway.

It's always annoyed me when authors tell you to "Click OK" at the end of each step, as if you're too stupid to figure out that if you don't, nothing will happen. I only wrote it once (okay, maybe twice), because it was necessary for the instruction.

There are many keyboard shortcuts within Photoshop which become second nature for some users. I've deliberately not noted them, and have left it up to you and your level of expertise and preference as to whether or not you'll use them. For each technique, I've tried to make these sometimes complicated instructions as simple as possible.

Most of the images used as samples are studio portraiture, although I've placed a few non-portrait samples here and there. The techniques I'm presenting, while wonderful for portrait photographers, are equally valuable for stock photographers and photographic fine artists. All of the first-state images are available for you to download so you can precisely follow my directions and get the same results you see in this book. Just log on to http://www.ChristopherGrey.com/booksamples.

As my disclaimer states, "Your results may be different". Not every image is perfect for every technique, but the techniques will work on any image. It's up to you to determine which of your existing images will work the best, and for which technique. After some practice, you may decide to actually shoot *for* a favorite look, adjusting camera exposure and lighting as necessary.

While the sequence of my instructions seems to work the best for the desired effect, the actual settings of the filters and adjustments should be played with, and I encourage you to do that, just to see what happens. If you discover something fantastic, please let me know (Chris@ChristopherGrey.com).

Thanks for supporting my work, and for the desire to create your own.

Christopher Grey

Acknowledgments

As always, writing a book is a tremendous undertaking; a commitment of time and energy that always takes more of each than was originally planned. Still, it was great fun to discover new applications for the wonderful tools inside Photoshop.

I'd like to thank everyone who sat for my camera for their time and energy as well. Your contribution is much appreciated: Jordi Antrim, Dominic Castino, Kim Dalros, Michael Dane, Bill Foster, Bill Fricke and Joette Poehler, Michelle Gonzalez, Molly Grace, Elizabeth Grey, Susan Grey, Jennifer Haldeman, Jennifer Hammers, Guy Jamal, Rachael Johnson, Ruth Koscielak, Katie Krall, Jessica Lee, Tammy Loheit, Tom McCarthy, Jim and Loy Mentzer, Steven Mentzer, Barbara Smith and Kaleigh Mentzer, Hannah Morcan, Isabella Ngo, Ali Perrier, Lela Phommasouvanh, Carrie Poehler, Danielle Polson, Lucia Radder, Hayley Riley, Jack Riley, Rebecca Riley, Kristen Rozanski, Kevin and Cassie Scheunemann, Megan Seefeld, Evangeline Stacy, Bo Tarkenton, Kaelin Vermilyea, Jennifer Zumbach.

Some very talented makeup artists also contributed to this project: Susan Grey, Jennifer Hammers, and Jennifer Holiday Quinn.

Thanks to Caryn International and the Academy of Screen and Television for access to some very talented individuals, and to Paul Hartley for the terrific author photo.

The Suzette Allen and Jonny Yoshinaga, thanks for the technical edit. Suzette is a Photoshop wizard whose input is always welcome; both are friends.

And, of course, thanks to my wife Sue and daughter Liz for putting up with yet another project. I'm hoping you'll have to deal with many more before all is said and done.

Christopher Grey

A Short Course in Layer Masks

Perhaps the two scariest words in Photoshop, "Layer Mask," should be no cause for alarm. It is simply a tool to work between an active layer and the layer below.

When I began teaching the techniques in this book, I deliberately avoided using Layer Masks because my audience, for the most part, simply did not understand them and were too afraid to try them in the time we had together. The mere mention of the words elicited groans and whimpers of the sort you, as a college student, might have uttered upon learning your Literature assignment for tomorrow was the first half of *Moby Dick*.

So, let me give you the short course in how they work. I know that if you play with the concept, even a little bit, you'll get the hang of it right away, and will understand how to use Layer Masks for your everyday retouching and enhancing duties (Figure 1).

A Layer Mask will not work on the original (Background) layer; it must first be duplicated,

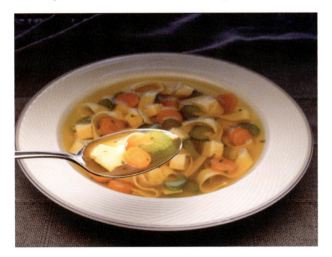

either via Layer>Duplicate Layer or by the keyboard shortcut Command-J for Mac, Control-J for pc. Let's set up an image for a typical Layer Mask application by opening the image and duplicating the layer (Figure 2).

With the duplicate layer selected, use Image>Adjustments>Desaturate to convert the layer to grayscale. Note that the layer icon has changed to reflect the grayscale image (Figure 3).

Figure 1

Figure 2 Figure 3

Layer Masks come in two varieties: white and black, and are accessible by selecting Layer>Layer Mask>Reveal All (a white mask is created) or Hide All (creates a black mask) (Figure 4).

Layer Masks may also be created by selecting the Layer Mask icon found on the bottom of the Layers Palette. Simply clicking on the icon (indicated in red) will create a white mask. For a black mask, hold down the Option key (for mac, Alt key for PC) while selecting the icon. I chose the white mask because I wanted to see only the grayscale image in order to work through it (Figure 5).

Choose the opposite Foreground color (black) to reveal what's below. In other words, painting, drawing, or filling a selection with the mask's opposite color will "erase" through it. For this image, I'll also select the Brush tool (Figure 6).

Figure 4

Figure 5

Figure 6

Now, to reveal the original color, I'll simply paint, with the Foreground color, over the portion of the image I want to see through. If I make a mistake, or stray outside the lines, I'll just reverse the Foreground/Background colors and paint the mask back in with white (Figure 7).

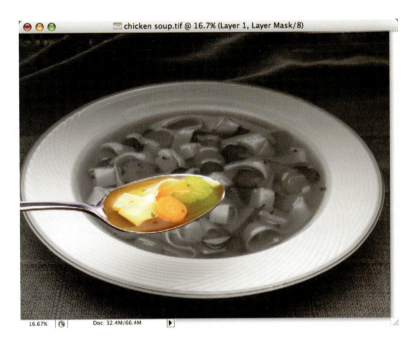

Figure 7

Figure 8

Should additional adjustments be necessary to the image itself, it may be worked at any time, independent of the mask, by clicking on the layer thumbnail icon on the active layer. You'll notice a small box will form around the icon, indicating that's what can be worked on (Figure 8).

For example, even though it's been desaturated, this is still an RGB image. Let's turn the bowl of soup into a sepia toned black and white through Image>Adjustments>Variations. Using the default settings, click once on yellow, once on red (Figure 9).

To see what the mask looks like (which may make it easier to paint), make sure the layer mask thumbnail is selected (look for the little box), hold down the Shift and Option (Alt for PC) keys and click on the icon. The mask will appear as its default color, red. Repeat to remove it (Figure 10).

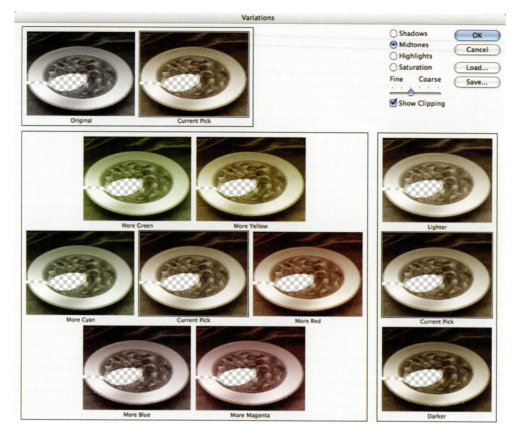

Figure 9

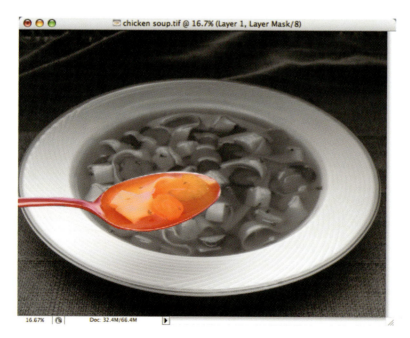

Figure 10

Simple, easy, and really effective.

If you have trouble remembering which is which, think of this: If you are working with a white mask, then "black reveals, white conceals", and for a black mask "white reveals, black conceals".

Also, if you want to do additional work on the Background Layer be sure to duplicate it first. It's good insurance to have a pristine version of the image always available (Figure 11).

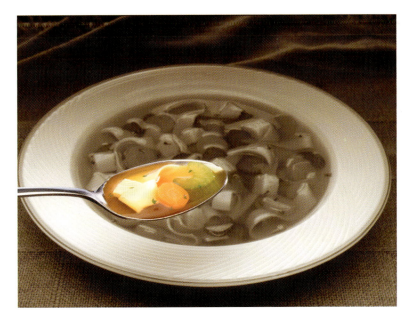

Figure 11

Section 1
Traditional Photographic Techniques

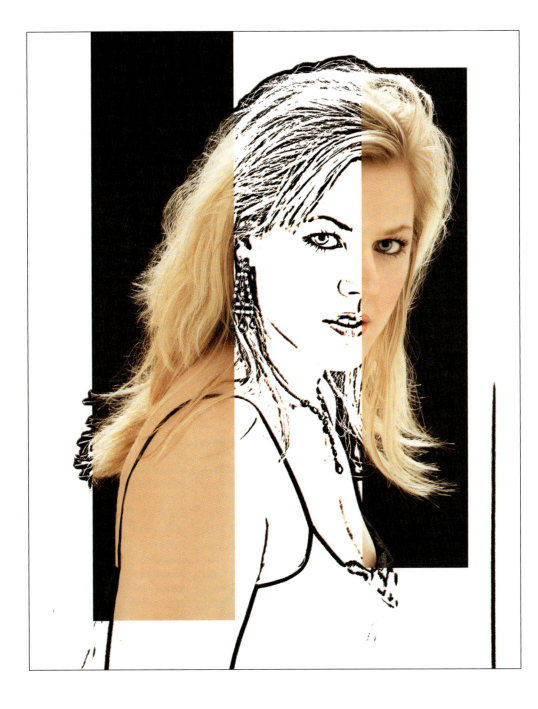

Creative Desaturation

While Photoshop is terrific for spicing up image color, it also offers a few tricks for spicing it down. However, if you use just the Desaturate tool (Image>Adjustments>Desaturate), the best you'll get is a basic grayscale image, as there are no degrees of adjustment with that tool. Useful, but not terribly versatile.

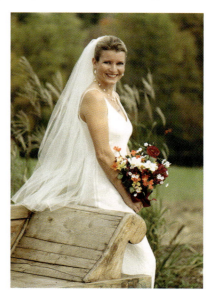

Working the Saturation slider at Image>Adjustments>Hue/Saturation to the left will gradually desaturate the image until all that is left is the same basic grayscale image.

You can also desaturate any selected color. This is especially useful if you'd like or need to change the color balance of an image and want more control than with Variations and less trial and error than with Color Balance.

Let's say we need to give an image the look of "Sweet Light" that magical color that appears just at sunset and only lasts a few minutes. Sweet Light varies in color, depending on a number of atmospheric factors, from warm yellow-orange to dusky rose:

Step 1 Open your image and duplicate the layer (Figure 1-1).

Figure 1-1

Step 2 From the Toolbox, select the Color Picker and find a color you like. I've chosen F67B7B, a rich pink (Figure 1-2).

Step 3 Fill the new layer with the chosen color (Edit > Fill). The Blending Mode should be Color (Figure 1-3).

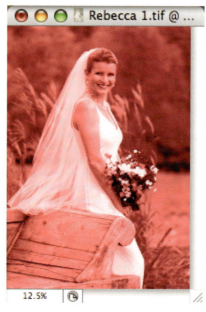

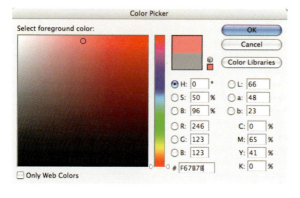

Figure 1-2

Figure 1-3

Figure 1-4

Figure 1-5

Step 4 Use the Layer Opacity slider to desaturate this color until you like it (Figure 1-4).

Step 5 Flatten and Save. The final image is both subtle and robust (Figure 1-5).

Figure 1-6

For those of you who shoot architectural or travel images, this method can make a good image great. For this shot I filled the duplicate layer with F5822E, a golden orange (Figures 1-6 and 1-7).

Photoshop introduced a new Image > Adjustments device in version CS, Photo Filter, which is designed to mimic the effects of glass camera filters. Its most useful filters are the warming and cooling filters, which act much like the old standards (Figure 1-8).

If you're working with a previous version of Photoshop, use the following colors as guides. To warm up your image, with color similar to the 85 filter series, use EC8A00. For a more subtle look, like the 81 series, use EBB113.

Figure 1-7

To cool an image, use 006DFF to match the 80 series, 005B5FF to match the 82 series. Another cooling filter, the LBB series, can be replicated with 005DFF.

Photo Filter hosts a number of other colors to choose from as well. I'll leave it to you to determine their value to your work.

For many photographers, images that are both color and black and white have become a staple product. They're easy to do with Photoshop; here's how.

Figure 1-8

Method one

Step 1 Open your selected image and duplicate the layer (Figure 1-9).

Step 2 Desaturate the new layer (Image > Adjustments > Desaturate) (Figure 1-10).

Step 3 Use a white Layer Mask to mask through the desaturated layer to the full color layer below. The selection mask for this image was created with the Polygonal Lasso, then filled with black (Edit > Fill) to see through to the layer below (Figure 1-11).

Figure 1-9

Method two

Step 1 Open the selected image. Using the Elliptical Marquee, the Rectangular Marquee, or the Lasso Tool, draw the appropriate shape. Move it into position, if necessary (Figure 1-12).

Step 2 Use Select > Inverse to work in the area outside of the drawn shape (Figure 1-13).

Step 3 Use Select > Feather and set a Feather Radius you like. Larger numbers mean a more gradual transition (Figure 1-14).

Figure 1-10

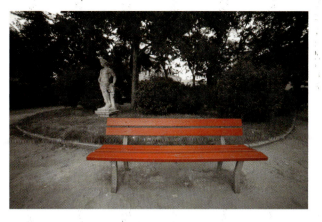

Figure 1-11

.Figure 1-12

Step 4 Select Image>Adjustments>Desaturate to turn the area outside the shape to grayscale (Figure 1-15).

Optional

Instead of Desaturating in Step 4, fill the area with black, white, or any color from the Color Picker. For this example, I've selected a color from the background. To blend the two layers I've reduced the Layer Opacity of the working layer to 60% (Figure 1-16).

If you would like to see the effect of other Blending Modes (which can be very dramatic) first use Select > Inverse to catch the inside of your shape, then Edit > Clear to eliminate those

All	⌘A
Deselect	⌘D
Reselect	⇧⌘D
Inverse	⇧⌘I
All Layers	⌥⌘A
Deselect Layers	
Similar Layers	
Color Range...	
Feather...	⌥⌘D
Modify	▶
Grow	
Similar	
Transform Selection	
Load Selection...	
Save Selection...	

Figure 1-13

Feather Selection

Feather Radius: 125 pixels

OK
Cancel

Figure 1-14

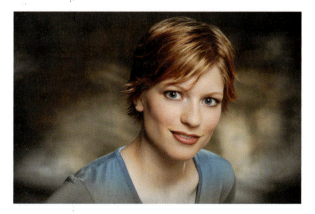

Figure 1-15

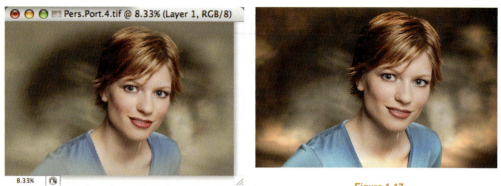

Figure 1-16

Figure 1-17

pixels (you'll see through to the layer below and it may look like nothing happened). Do Select>
Inverse again to be certain that any additional steps will be applied to the outside of the shape.
This example's Blending Mode was Vivid Light (Figure 1-17).

Organic Vignettes

As much as I love the digital evolution, there are some analog techniques I really miss. After making thousands of prints in the darkroom, I got rather good at sticking my fist under the enlarger head and, by adding exposure time, making vignettes around my subjects. Using my hand allowed more shape variety than I could ever get out of a wand, whether I cut a custom shape or not, and gave the vignette an organic appearance.

A vignette adds a subtle depth to an image, to be sure, but it also differentiates between amateur and professional.

Let's say you're shooting a wedding. If you're like many photographers, you allow relatives to shoot their versions of the formals after you're done. With today's equipment, there's a good chance that Uncle Roy's shot will look a lot like yours (at least to Uncle Roy). A vignette is a simple way to make your image look more professional (which means your sample book images need vignettes, too).

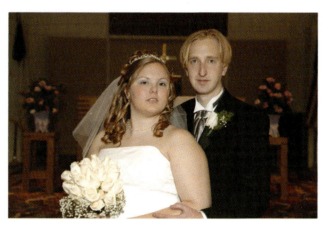

Figure 1-18

Dark vignettes

Step 1 Open the image and duplicate the layer (Figure 1-18).

Step 2 Using the Lasso tool, freehand a shape around the subjects, roughly following their outlines but coming across the bottom. If you get too close, just undo it and start over (Figure 1-19).

Step 3 Go to Select>Inverse, which will allow you to work outside of the selection, then Select> Feather. Generally speaking, the larger the image the larger the feather required to keep the transition soft. Photoshop allows a feather radius up to 250 pixels, and I've found a radius of 150 to be perfect for images around

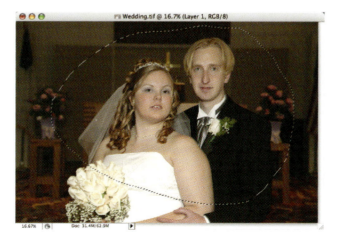

Figure 1-19

Figure 1-20

8×10 in size. You'll notice the rough edges of the Lasso selection will soften after Feather is applied (Figure 1-20).

Step 4 Now use Image> Adjustments>Hue/Saturation. Select the Lightness slider and move it to the left to darken outside the selection. There's no need to do the entire vignette at once, although that is an option, so I suggest a maximum darkening of 20% (Figure 1-21).

Step 5 Select>Deselect to eliminate the Lasso selection, then duplicate the working layer. Draw another shape with the Lasso tool, further away from the subjects (Figure 1-22).

Step 6 Repeat Step 3 with the same feather amount, then repeat Step 4. You'll begin to see the effect of multiple vignettes (Figure 1-23).

Step 7 Deselect the Lasso and duplicate the layer again. This time, just draw to accent the corners (Figure 1-24).

Step 8 If you're happy with the third selection and the overall look of the image, Flatten and Save or add more vignettes until you get something you like (Figure 1-25).

Figure 1-21

Figure 1-22

Figure 1-23

Figure 1-24

Figure 1-25

Figure 1-26

White vignettes

Studio portraiture benefits just as much, if not more, when vignettes are employed to add visual interest.

Back in the darkroom, we would make a white vignette by printing through a hole in black paper, protecting the edges of the enlarging paper from exposure. This was impossible to achieve unless the print was made in studio or by a custom lab, as machine prints typically do not allow any "hands-on" manipulations. Now, with Photoshop, it's extremely easy:

Step 1 Open the selected image. It's not necessary to duplicate the layer, you can simply undo any mistakes (Figure 1-26).

Step 2 Use the Lasso tool to freehand a selection around the group (Figure 1-27).

Step 3 Select>Inverse will allow the effects to happen outside the selected area, then Select>Feather for the transition area. For this image I set the pixel radius at 100 (Figure 1-28).

Step 4 Edit>Fill will call up another selection box. Select White at 100%. Blending Mode is Normal (Figure 1-29).

Gradient color vignettes

Photoshop allows variations on the vignette theme that were all but impossible in the

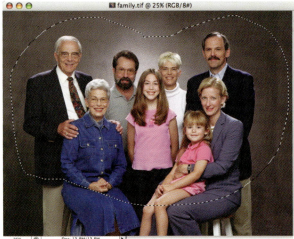

Figure 1-27

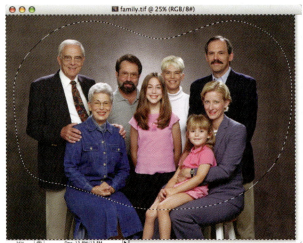

Figure 1-28

Figure 1-29

darkroom or in the camera. The next time you make an image that is predominately one color, try this technique; you might be pleasantly surprised:

Step 1 Open the selected image. As with the white vignette, it's not necessary to duplicate the layer (Figure 1-30).

Step 2 Use the Color Picker to select new Foreground and Background colors. The sample image shows a nice progression of color, light to dark, from top to bottom, and I'll maintain the same order (Figure 1-31).

Step 3 Select the Elliptical Marquee and draw an oval around the subject. Select>Inverse to apply your effects to the outside of the selection, then use Select> Feather. I set the pixel radius for this sample at 150 pixels, even though the image size is small, about 10 MB, for an extremely soft transition (Figure 1-32).

Step 4 From the Toolbox, select the Gradient tool. A submenu will appear just above the Picture Window; for a light-to-dark gradient click on the very first icon, the Linear Gradient. Note that the Blending Mode defaults to Normal, Opacity to 100% (Figures 1-33 and 1-34).

Step 5 Fill the selection by holding down the cursor and drawing a line, starting somewhere above the middle, ending somewhere below the middle. The abruptness of the

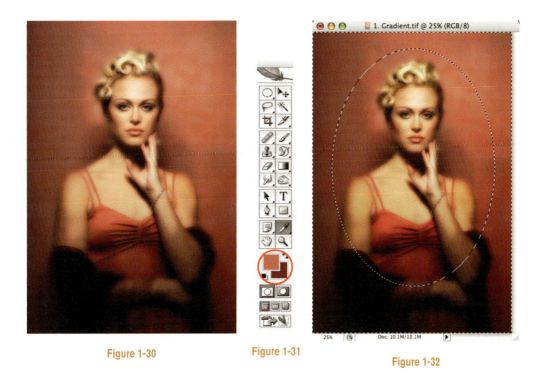

Figure 1-30

Figure 1-31

Figure 1-32

Figure 1-33

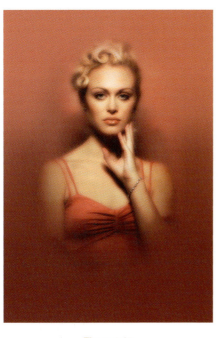

Figure 1-35

Figure 1-34

transition between the Foreground and Background color is determined by the length of the line you draw (Figure 1-35).

Desaturated vignette

Step 1 Open the selected image (Figure 1-36).

Step 2 Grab the Rectangular Marquee and draw a shape inside the borders (Figure 1-37).

Step 3 Select>Inverse to apply the effect outside the selection, Select>Feather. This image was feathered at 50 pixels for a more abrupt transition (Figure 1-38).

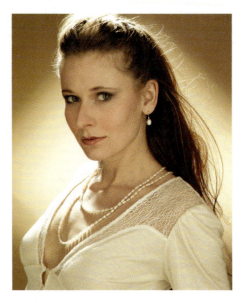

Figure 1-36

Figure 1-37

Figure 1-38

Step 4 Use Image>Adjustments>Desaturate to desaturate either partially or completely (Figure 1-39).

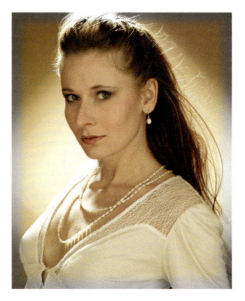

Figure 1-39

Converting Color to Grayscale

Method one: Grayscale

Although it's a simple matter to change the mode of a color image to black and white (grayscale) via Image>Mode>Grayscale, it may not be the best way, at least if reproduction quality is one of your goals.

 Although they require extra steps, there are several other methods that will work better. I'll use an image with a short tonal range so that you can judge the quality of the conversion to black and white (Figure 1-40).

 For comparison, here is the Image>Mode>Grayscale image. This image, as well as the rest, will be presented without any Levels or Curves tweaks, in order to more accurately judge the tonal qualities of each (Figure 1-41).

Figure 1-40

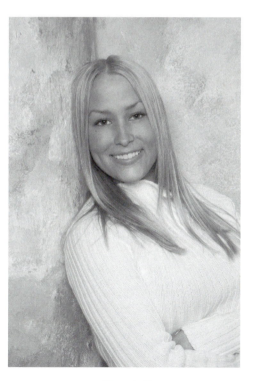

Figure 1-41

Figure 1-42

Figure 1-43

Method two: Lab color

Step 1 Change the Mode of the image to LAB color by Image>Mode>Lab Color (Figure 1-42).

Step 2 From the Layers window, select Channels (Figure 1-43).

Step 3 Select the Lightness channel (Figure 1-44).

Step 4 Eliminate the unused LAB channels; Image>Mode>Grayscale will convert this selection o a grayscale image while keeping the tonalities intact. You can convert this back to an RGB file through Image>Mode>RGB Color if you need to apply color effects like sepia toning. You'll be asked if you want to discard the other channels. You do (Figure 1-45).

Step 5 The Lab to grayscale conversion did a better job on the skin tones and kept more detail in her light hair (Figure 1-46).

Figure 1-44

Figure 1-45

Method three: Channel Mixer

Step 1 With your image open, go to Image>Adjustments>Channel Mixer. Select Monochrome. Note the 100% default limit on the Red Channel (Figure 1-47).

Step 2 The 100% limit means that you can change the combination of Source channel strengths (Red, Green, and Blue) in an almost infinite variety, as long as they total about 100%. More than 100% will overexpose something, less will underexpose.

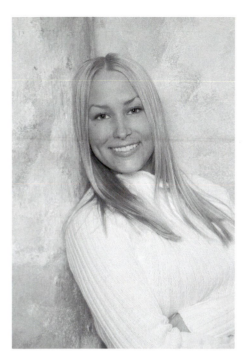

Figure 1-46

Figure 1-47

Figure 1-48

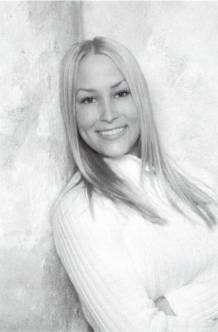

Figure 1-49

By moving the RGB sliders, the overall look of the image can be changed. I usually begin with 60% Red Channel and 40% Green Channel and tweak from there. As long as the total of the three sliders is close to 100 you'll be fine. I've "cheated" here, just a bit, and went over the 100 total in order to brighten the whites (Figure 1-48).

Step 3 This method, while not my personal favorite because it takes a fair amount of time and is dependent on the quality of the monitor to judge the slider's effectiveness, yields a very nice conversion (Figure 1-49).

Figure 1-50

Figure 1-51

Figure 1-52

Figure 1-53

Method four: Hue/Saturation

In my opinion, this method offers the most variety and is very easy to master, although it's not always the best choice. In the final step, the use of the slider immediately shows the effect of any of the classic black and white lens filters – yellow, green, red – and all shades in between, as if you had those filters on the camera during the shoot:

Step 1 From the submenu bar at the bottom of the Layers window, create a new Adjustment layer by clicking on the New Fill or Adjustment Layer icon (Figure 1-50).

Step 2 From the pop up menu, select Hue/Saturation (Figure 1-51).

Step 3 The Hue/Saturation window will appear. Just click OK without making any changes (Figure 1-52).

Step 4 Make another Hue/Saturation Adjustment layer the same way. This time, move the Hue/Saturation slider all the way to the left to desaturate the image (Figure 1-53).

Step 5 Set the Blend Mode of the newest layer to Color (Figure 1-54).

Step 6 In the Layers window, click on the first Hue/Saturation icon which will open the Hue/Saturation window (Figure 1-55).

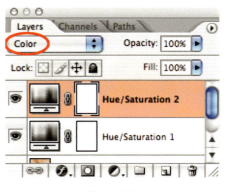

Figure 1-54

Figure 1-55

Figure 1-56

Figure 1-57

Step 7 Drag the Hue slider back and forth until you find a combination you like (Figure 1-56).

Step 8 Racking through the slider variations is like looking at the effects of a virtually infinite number of on-camera filters (Figure 1-57).

Each of these conversion methods brings something different to the parade. If you're ever in doubt whether or not your conversion looks good, run through these variations and pick the best one.

Short Focus

One of the things I enjoyed most about analog photography was the extremely short focus I could achieve with a view camera. By placing the swings and tilts into "illegal" positions, it was possible to go from a point of sharp focus to a substantial blur over a small distance.

Portrait photographers who shot view cameras and who have switched to digital must be particularly chagrined over the loss of this creative control. Fortunately, Photoshop rides to the rescue with a simple technique, easy to master, that will take less time to apply than it once did to set up the camera:

Step 1 Open the image and duplicate the layer. Take a moment to study the picture and decide which plane or area you'll allow to stay sharp. The obvious choice for this image is across the man's face and shoulders, with a little emphasis on the camera left side (Figure 1-58).

Step 2 Select Blur>Gaussian Blur and a relatively high radius, somewhere around 40 pixels. It may be difficult to land the slider perfectly on 40, but you can just type it in, if you wish (Figure 1-59).

Step 3 Create a white Layer Mask from the Layers palette (Figure 1-60).

Step 4 Select a large, soft-edge brush and set its hardness at 50% (Figure 1-61).

Step 5 Set the Brush Opacity at 70% and paint, with black, over the portion(s) of the image that will

Figure 1-58

Figure 1-59

Figure 1-60

Figure 1-61

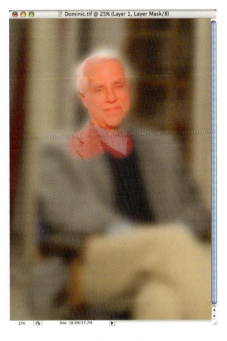

Figure 1-62

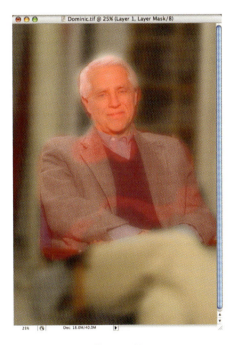

Figure 1-63

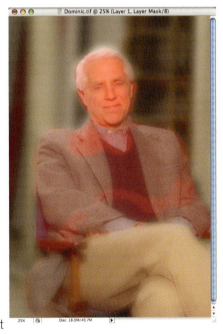

Figure 1-64

be the sharpest. Don't worry about being critically sharp, we'll deal with that later. If you want to see what your mask looks like, hold down the Shift and Option/Alt keys and click on the Mask icon in the Layers Palette. After this first step, my mask looked like this (Figure 1-62).

Step 6 Reduce the Brush Opacity to 40% and mask the next area (there is no formula for determining this; it's all up to you). Vary the brush size as appropriate to the size of the area and don't worry about painting outside the lines (Figure 1-63).

Step 7 Reduce the Brush Opacity to 20% and mask the next portion (Figure 1-64).

Figure 1-65

Figure 1-67

Figure 1-66

Step 8 If you've had the Mask visible, deselect it by holding down the Shift and Option buttons and clicking on the Mask icon in the Layers Palette. This is looking nice but there is still some retouching to do (Figure 1-65).

Step 9 Exchange the Foreground/Background colors so you'll be painting with white, then set the Brush Opacity at 10%. Using a smaller brush and multiple strokes, feather those areas where you painted outside the lines back to a level of softness equal to the surrounding area. If you mess up, or you see an area you would like to be sharper, just switch to black and paint over the area in question (Figure 1-66).

Step 10 Reselect Black, reset the Brush Opacity to 70% and feather in the portion of the face you want to be the sharpest. I said earlier that we'd favor the camera left side, so that's were I concentrated this last bit of masking. Flatten and Save (Figure 1-67).

You can vary the effect by using more or less Gaussian Blur or different percentages of Brush Opacity. The final retouch has always worked best for me at 10% with a feathered stroke.

Short Focus (Light)

This accomplishes much of the same thing as the original Short Focus text, except that it works from the outside in, and is meant to accent only those edges you wish to accent. It also seems to work best (at least for me) on an image with a solid background:

Step 1 Open the selected image and duplicate the layer (Figure 1-68).

Step 2 On the Duplicate Layer, use Levels and brighten the whites slightly, until they blow out by ± 10%. Depending on your taste, you may consider this an optional step (Figure 1-69).

Figure 1-68

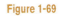

Figure 1-69

Step 3 Select Blur>Gaussian Blur. Set the Radius to ±40 (Figure 1-70).

Step 4 Create a black Layer Mask by holding down the Option/Alt key while clicking on the Layer Mask icon at the bottom of the Layers Palette. Working with a black mask means you'll be applying blurred highlight effects from a layer you can't see, so you can place them more accurately (Figure 1-71).

Figure 1-70

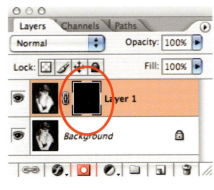
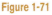

Figure 1-71

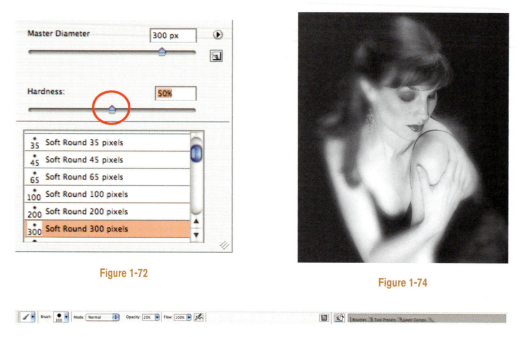

Figure 1-72

Figure 1-74

Figure 1-73

Step 5 Select a large, soft-edge brush at 50% Hardness (Figure 1-72).

Step 6 Set the Brush Opacity at 20% (Figure 1-73).

Step 7 Paint the Mask with white, feathering as you go with multiple strokes, until the desired effect is achieved. Remember, if you mess up, either Undo or paint over with black (Figure 1-74).

Black and White Infrared

The look of black and white infrared is truly unique within the realm of photography. Recording a portion of the spectrum that is invisible to the naked eye, genuine infrared portraits have a surreal quality that is both interesting and arresting.

Before we begin, understand that this technique is a replication of the studio application of infrared film. If you apply it to a landscape image it will not look like a genuine infrared photograph. That said, it's also true to say that it will look genuine when applied to people shot in a studio.

There is some interest these days in modifying the camera itself, removing the manufacturer's infrared filter so that every picture is made with predominately infrared light. This technological twist is nifty but permanent, and has one drawback that I see; film-based black and white infrared photography is never critically sharp or without a noticeable grain structure. Photographs made with reworked equipment are perfectly sharp and smooth, without grain. Skin tones, to me, look rather porcelain.

The infrared look is heightened a bit if your subject wears red or is positioned before a red (or reddish) background, but it's not mandatory, as you will see:

Step 1 Begin by duplicating the image (not the layer) via Image>Duplicate (Figure 1-75).

Step 2 Using the original image, select Channels from the Layers Palette, then select the Red channel (Figure 1-76).

Step 3 Use Image>Mode>Grayscale to eliminate all color data (Figure 1-77).

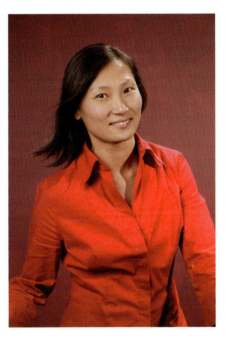

Figure 1-75

Figure 1-76

Figure 1-77

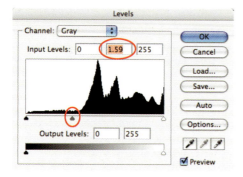

Figure 1-78

Step 4 Select Levels, then boost the midtones to a point you like between 1.5 and 2.0. This image sets the midtones at 1.59 (Figures 1-78 and 1-79).

Step 5 Infrared film is not critically sharp. Select Filter>Blur>Gaussian Blur, then set the radius to 1.5 pixels (Figure 1-80).

Step 6 Duplicate the layer (Figure 1-81).

Step 7 Add grain by selecting Filter>Texture>Grain>Regular. Set the Intensity to 45 and the Contrast to 50 (Figure 1-82).

Step 8 You may use the Opacity slider to soften the Grain effect, if you wish (I did not). If you'd like more contrast, duplicate the top layer and set the Blending Mode to Soft Light or Overlay (for even more contrast) (Figures 1-83–1-85).

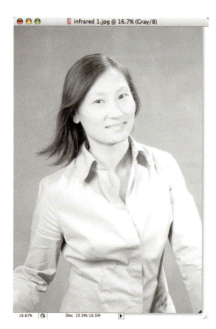

Figure 1-79

Figure 1-80

Figure 1-81

Figure 1-82

Step 9 If you'd like a more dense image overall, without compromising the tonal relations, set the Blending Mode of the newest layer to Multiply, which doubles the density. Use the Opacity slider if necessary to tweak the layer mix. For my final image, I've reduced the opacity of the Multiply image to 65% (Figures 1-86 and 1-87).

Here's a bonus procedure.

You're aware, no doubt, that you have two images on your desktop; the original, now seen in its infrared Grayscale form and the copy, still a full color RGB. If you're happy with the infrared

Figure 1-83

Figure 1-84

Figure 1-85

Figure 1-86

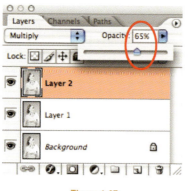

Figure 1-87

Figure 1-88

image you've been working on, Flatten and Save it, but leave it open on the desktop. Then, Select>All and Edit>Copy the flattened Grayscale.

Paste the Grayscale image over the duplicate color image, automatically converting it to an RGB layer. Leave the Blending Mode to its default setting, Normal. Use the opacity slider to adjust the two layers to get a beautiful pastel image that incorporates the best of a full color and infrared image (Figure 1-88).

I said earlier that red clothing or background might be helpful. When an object or area that is substantially red is broken down into its channels, the extra red will make the red channel image appear lighter, a characteristic of infrared film. My technique does not rely on that, however, and will work well with any studio portrait (Figure 1-89).

For the final image, Levels were set at 1.55, and no additional layers were used to adjust contrast or detail (Figure 1-90).

Figure 1-89

Figure 1-90

Cross-Processing

Cross-processing, where film meant for one type of chemistry, like E-6, is processed in chemistry meant for another film, like C-41, has been a staple of film photographers for years. When properly done, results looked sort of normal, but with color changes that made them "edgy" and cool.

While I've frequently been quite impressed with cross-processed images, I've never been happy with the finality of it. Once you commit to the procedure, there is no turning back. Your pictures can never look "normal" again.

With that in mind, here's my version of digital cross-processing. Unlike the chemical process, which limits the number of "looks" to the varieties of film and developers, variations on my technique are virtually infinite.

To begin, we need to pick one color from within the image to influence its final look, and change a correctly white balanced image to a "tungsten film shot with daylight" look:

Step 1 Duplicate the Layer (Figure 1-91).

Step 2 When film balanced for tungsten light was photographed under daylight conditions, the results had a heavy cyan cast. Select the Color Picker and type in 00ADEF in the box at the bottom. Click OK and the Foreground color will be Photoshop's vision of pure cyan (Figure 1-92).

Step 3 Use the double arrow on the Toolbox to exchange the Foreground and Background colors (Figure 1-93).

Step 4 With the Eyedropper, select the color found in a bright section of skin tone. If you're working on a still life or other non-human image, pick a color that you'll be comfortable with (Figure 1-94).

Figure 1-91

Figure 1-92

Figure 1-95

Figure 1-93

Figure 1-94

Figure 1-96A

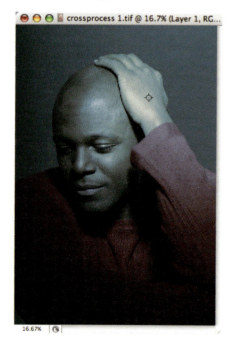

Step 5 Go back to the Toolbox and select the Foreground color. When the Color Picker opens you'll see the exact color you chose. Move the cursor on a straight line to the right to get a stronger hue (Figure 1-95).

Step 6 Fill the Duplicate Layer (Layer 1) at 50% (Edit>Fill). Select Foreground Color, set the Blending Mode selection in the Fill box to Color, and check the "Preserve Transparency" box (Figure 1-96A and B).

Figure 1-96B

Figure 1-97

Figure 1-98

Figure 1-99

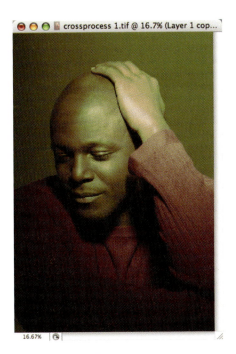

Figure 1-100

Step 7 Alter the Hue and Saturation of the Layer. (Image>Adjustments>Hue/Saturation) Slide Hue to −50 and Saturation to +30 (Figures 1-97 and 1-98).

Step 8 Duplicate Layer 1 ("Layer 1 copy") and use Edit>Fill once again. Select Background Color, which will use the skin tone variation chosen in Step 5, and the same settings as Step 6 (Figures 1-99 and 1-100).

Step 9 You can stop here, if you wish, or take it a few steps further by doing any of the following:

– Select Layer 1 copy, slide the Opacity at 65% and set its Blending Mode to Darken (also try Lighten). Call up the Hue/Saturation window and walk the Hue slider back and forth until you find a combination you like (Figures 1-101 and 1-102).

Or

– Change Layer 1 copy's Blending Mode to Hue, with an Opacity of 75%. Select Layer 1 and call up the Hue/Saturation window. Walk the Hue slider as before (Figures 1-103 and 1-104).

– Reselect Layer 1 copy and call up the Hue/Saturation window and work the slider magic one more time (Figures 1-105 and 1-106).

Figure 1-101

Figure 1-102

Figure 1-103

Figure 1-104

Figure 1-105

The possibilities, as they say, are endless because you don't have to stop here. Try additional layers in other Blending Modes or go back to the start and choose a different color for your first fill. Try Fill and Opacity percentages different from my guidelines.

As with all of my techniques, I encourage you to play and expand on them.

crossprocess 1.tif @ 16.7% (Layer 1 cop...

16.67%

Figure 1-106

To find the *exact* opposite of any sampled color, do this:

Step 1 At any time in the procedure, use the Rectangular or Elliptical Marquee and draw a small shape on your image.

Step 2 Fill that selection with the sampled Foreground color. The Blending Mode should be Normal, fill at 100%, do not select Preserve Transparency.

Step 3 Image>Adjustments>Invert to reverse the color.

Step 4 Sample the new color with the Eyedropper tool. The new color will show up on the Toolbox as a new Foreground color.

Step 5 Select the Color Picker and make note of the color's number.

Step 6 Back up on the History Log and reselect the last thing you did before you drew the marquee. Everything you just did on the picture will disappear but you'll have the color information you need.

High-Speed Film Grain

Back in the 1960s, had you searched for a high ISO color slide film with clean, bright, whites and deep, rich, blacks, you would never have used more than one roll of Dynachrome 1600. When push processed to ISO 3200 or beyond, however, the images were almost magical. Saturated colors became pastels, shadows became softer, and highlights spread out slightly from their source. These changes were complemented by a very large grain structure, all of which meant images that looked unlike anything else available.

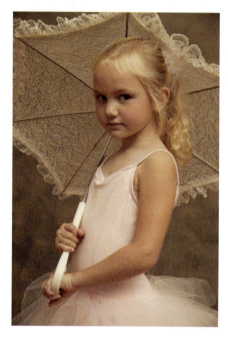

The film was discontinued years ago, much to the chagrin of many poster, card, and book publishers, who seemed to print almost every Dynachrome image they could buy.

Close runners-up to getting the same effect included Agfachrome 1000 and Kodak's High-Speed Ektachrome. While the images were interesting, neither of these emulsions showed the charm that seemed to come naturally to those created by Dynachrome.

By the way, my experience indicates this will work best with images that are not too contrasty, perhaps even a bit flat or slightly underexposed. If you opt for underexposure, don't go much beyond the 1/2 stop digital latitude limit. When you adjust the levels of a more severely underexposed image, the highlights of the adjusted image may be too bright for this technique to be believable (Figure 1-107):

Figure 1-107

Step 1 Begin by duplicating the Layer. Dynachrome's shadows typically showed a blue tinge in the shadows. This was perhaps the basis for its charm, as Agfachrome's were slightly red and Ektachrome's were almost neutral.

Step 2 Select a deep blue from the color palette. Be sure to make a note of the reference number in case you want to duplicate it again. For this image I'm using 3942F3 (Figure 1-108).

Figure 1-108

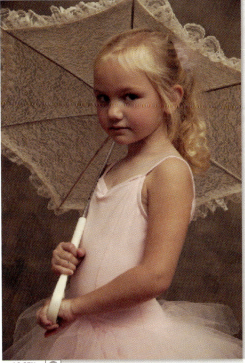

Figure 1-109

Step 3 Fill the duplicate layer with the chosen color. First, select Edit > Fill. Then, in the Fill window: (1) set the Blending Mode to Color; (2) set Opacity to 5%; and (3) be sure to select Preserve Transparency by clicking on it (Figure 1-109).

Dynachrome transparencies, especially when push processed, typically showed a little extra contrast on the high end, which looked like the photographer added a very minimal soft focus filter, although shooters frequently exploited the effect by adding real soft focus filters. To get our initial filter effect, we'll use Filter > Distort > Diffuse Glow. Diffuse Glow adds a little grain of its own, while increasing contrast, which will allow tonal separation when we add the actual grain layer.

Step 4 Select the Diffuse Glow filter. I'll start with the following settings, but, as always, it's up to you to determine what you like. Set Graininess to 8, set Glow Amount to 2, a slight adjustment, then Glow Amount to 10 (Figure 1-110).

This film was not noted for sharpness, so we'll have to take that down a bit.

Step 5 Select Filter>Blur>Gaussian Blur. This will be a minimal application, so select a spread between 1 and 2 pixels. Your image and experience with this will make the determination (Figure 1-111).

Now, add the grain that will give the picture its final look.

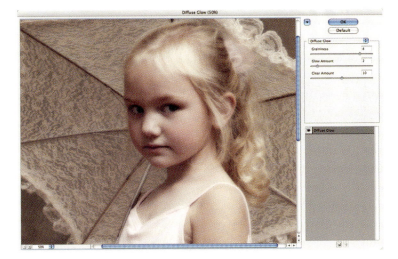

Figure 1-110

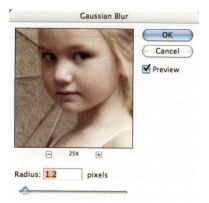

Figure 1-111

Step 6 Duplicate the working effects layer, then select the Filter menu. Go to Filter>Texture>Grain>Enlarged. Set the Intensity at 50%; set Contrast to 0 (which will keep potential light/dark changes to a minimum) (Figure 1-112).

Personally, I've never been a big fan of Photoshop's out-of-the-gate grain effects. They look like overgrown RGB noise (which is probably all it actually is). Just enlarge your image to 100% to see what I mean. To make the grain look normal, do the following.

Step 7 Set the Blending Mode of the Grain layer to Luminosity, which will convert the grain effect from RGB to monochromatic (Figure 1-113).

Step 8 Flatten and Save when you're happy. To convert the effect to black and white refer to any of the approved methods in Section 1, Chapter 3 *Converting Color to Grayscale* (Figure 1-114).

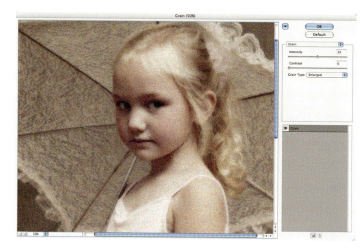

Figure 1-112

Figure 1-113

Figure 1-114

Oil Tint

What began as a method to colorize early black and white images took on a life of its own, becoming an assembly line staple of many early portrait studios. Quality varied from studio to studio, and, as expected, some were terrific; some were not. Even with variations in quality, the technique was very popular. Just about every photograph was fair game for the tinters, even shots from the "Instant Photo" booths (Figure Old photo).

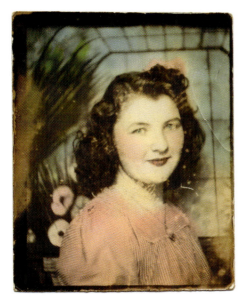

Old photo

Couple the ease of doing this digitally with its cool, retro look and it's entirely possible that this technique could make a lot of money for your studio.

Well-painted images look almost like a real color photograph. Subtle differences, even "mistakes", contribute to the charm:

Step 1 Begin by duplicating the image (Image>Duplicate). Reduce the size of the original and move it off to the side for now (Figure 1-115).

Step 2 Duplicate the layer of the duplicate image and desaturate it to get an RGB grayscale version, then duplicate that layer again (Image> Adjustments>Desaturate) (Figure 1-116).

Figure 1-115

Figure 1-116

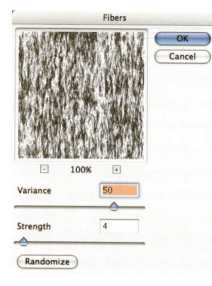

Figure 1-117

Figure 1-118

Figure 1-119

Step 3 When a fiber-based print is oil tinted, some color gets through the emulsion and into the grain of the paper itself. The resulting little flecks of darker color contributed to the look of the oil tint, and we can replicate that effect by using Filter>Render>Fibers. For this 8×10, I've set the Variance to 50 and Strength to 4. You will need to experiment with different settings for larger or smaller prints, as the scale of the effect should be reasonably consistent from size to size it should be almost unnoticeable. Fibers was introduced in Photoshop CS, so if you're working with an earlier version you will not have this option. Please note that Fibers take its color from the Foreground color, so be certain that the Foreground color is black. You can lessen the effect by using a deep gray such as 4F4D4E (Figure 1-117).

Step 4 After applying the Fibers filter, set the Opacity of the layer to 15% and its Blending Mode to Soft Light (Figure 1-118).

Step 5 Merge the two layers (Layers>Merge Down). Your working layer should look something like this (Figure 1-119).

Step 6 Genuine oil tints were made on sepia toned, fiber base prints. Because oil tints are not opaque, and the tints are rather "thin" colors that were simply rubbed on the prints with cotton balls, the toning added to the authenticity of the flesh tones. Sepia is merely yellow and red, and we can easily replicate that color using Image> Adjustments>Variations.

With Midtones selected, set the intensity slider to Fine. Click on More Yellow twice, then click More Red three times. Obviously, if your taste dictates otherwise, you can easily use more or less color just by changing the number of clicks (Figure 1-120).

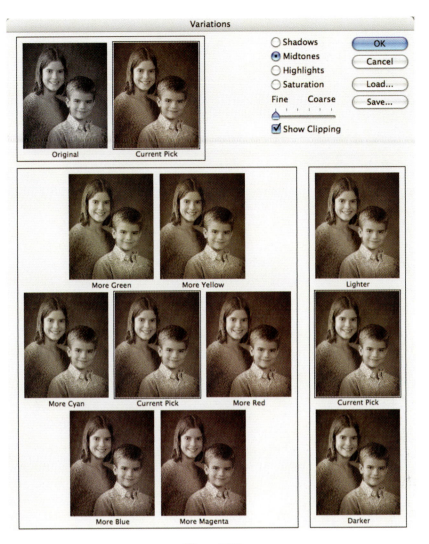

Figure 1-120

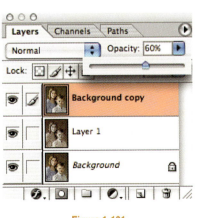

Figure 1-121

Step 7 Reselect the original, untouched Background Layer and copy it. Grab it with the cursor and move it to the top, above the sepia image. Slide the Opacity of the new layer down to about 60% (Figure 1-121). If you were to stop now, you'd have a passable reproduction of the oil tint process. The colors are soft, and there is an impression of fiber and realistic color. A few more hands-on steps will complete the illusion and create an exemplary product (Figure 1-122).

There were two other signature features of oil tinting. The first was the addition of color to add emphasis to features and clothing. Because we're using a color photograph as our "paint", there's a danger the image will look too real, so we must create

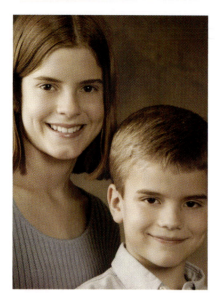

Figure 1-122

Figure 1-123

some surreality to complement the image. It was also difficult, when applying color, to stay inside the lines. I know it's unbelievable, but here's a digital technique where slop counts.

Step 8 Begin by creating a new layer from the Layer menu (Layer>New>Layer). When the selection box appears, select "Color" for the Blending Mode, 100% Opacity. We'll use this layer to enhance the pastel colors as they appear now (Figure 1-123).

Step 9 Go back to the original, untouched, color image. Duplicate the layer and use Image>Adjustments>Hue/Saturation and increase the saturation of the new layer to +20%. These are the colors we will work from (Figure 1-124).

Figure 1-124

Step 10 Use the Eyedropper tool and select a flesh tone from the original. I'll begin with the young woman, and select a median tone from her forehead (it doesn't have to be an exact middle tone). Select a large, soft-edged brush from the brush menu. A diameter roughly 1/3 the size of the area you wish to cover should be sufficient. This image, for example, requires a brush 300 pixels wide. Set the Brush Opacity (found at the top, under the Menu Bar) to 50% (Figures 1-125 and 1-126).

Figure 1-125

Step 11 Go back to the target image and paint the color over her face. Because we're working at 50% Opacity we can build color density by adding additional strokes over the darker parts of her face. Don't worry about getting color in the eyes or teeth, or painting outside the lines. We'll deal with both of those issues later. Repeat the color selection/brush

Figure 1-126

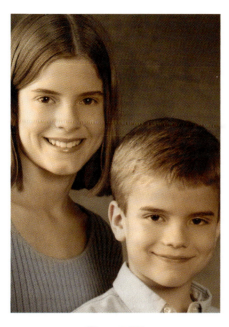

Figure 1-127

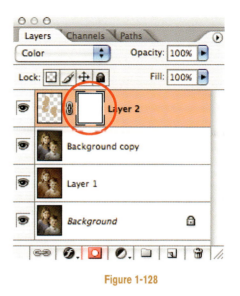

Figure 1-128

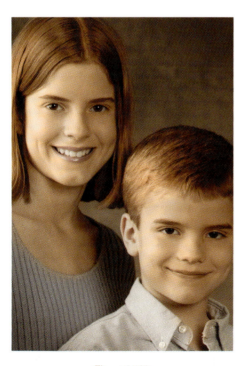

Figure 1-129

selection process with the boy, then do his face the same way. Add more color to the subjects' hair, varying the brush size as necessary to cover the area. Your effort will look like this (Figure 1-127).

Step 12 Now, we'll clean up the spilled color on this layer. Oil tint artists used a solvent; we'll use a white Layer Mask created through the Layer Mask icon at the bottom of the Layers Palette (Figure 1-128).

Step 13 Using brush sizes that fit the areas to be cleaned, eliminate the color where it doesn't belong: eyes, teeth, and lips, around the edges, by painting with black as the Foreground color. The result looks a little goofy, but don't worry about it (Figure 1-129).

Step 14 Create a New Layer as we did in Step 8. From the saturated original, select the lip color. Using appropriately sized brushes, paint the lips. Add another stroke or two in the shadow areas, to increase the color saturation and add to the illusion of paint. To add a little color to the cheeks, reset the Opacity of the brush to 25%, select a larger brush, and paint lightly, with the lip color, on both cheeks. Sample the eye color and do the same for both sets of eyes. Choose the brightest section of saturated color for your sample (Figure 1-130).

Step 15 Create another transparent layer as in Step 8, to be used for the clothing color. Select the clothing colors as in Step 10. For this brother and sister, her clothing was easy, as her

Figure 1-130

Figure 1-131

top was nicely and evenly colored. The boy's shirt was a normal, non-descript color, so we'll improvise by selecting a median color, then the Color Picker Menu, then an adjacent, brighter, and more saturated selection. The truest blue came from the fold at his shoulder, but was rather plain. The color I'll actually use comes from a slightly more dynamic color, just to the right and slightly higher on the Color Picker than the original (Figures 1-131 and 1-132).

Step 16 Create one more Layer Mask to clean up any mispainted details on this layer.

You may continue, if you wish, and create other layers and masks for the background, or, perhaps, for subjects wearing non-coordinated clothing or for special props. When you're happy, and all your ducks are in a row, Flatten and Save. Then print and price accordingly. Someday you'll thank me for this (Figure 1-133).

Figure 1-132

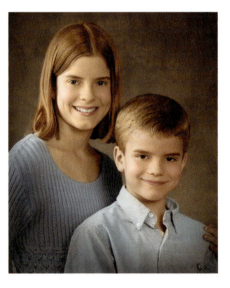

Figure 1-133

Hand Coloring Black and White

Hand coloring black and white photographs, even if you don't have a color image for reference, is rather easy. In essence, we'll be using a palette of set colors, just like hand colorists have used for decades. The only difference is that our palette is digital.

I remember, years ago, watching a colorist working on a copy print of an old family image. All she had to work with for reference was a few notes made by the client. Eye and hair color were pretty definite, but everything else, while noted, was simply presumed. It was up to her, as an artist, to fill in the blanks, which she did from a box of tints only 64 colors deep. It didn't take her very long to do a portrait, less than an hour as I recall, but, since hand coloring was her primary job and she really knew what she was doing, the dozens she did each week were accomplished with confidence and speed.

I guess that little digression means that you shouldn't be too concerned if your first attempts are less than stellar. Like every artistic technique, the secret to success is practice, practice, practice.

If you are beginning with a color image, you have the benefit of an actual color reference. If not, we'll reference Photoshop's Swatches window, a mini-palette with more colors than hand colorists ever had in the past.

Make sure your black and white image is in the RGB Mode. If in doubt, just use Image>Mode>RGB Color:

Step 1 Open the image (Figure 1-134).

Step 2 Duplicate the layer twice so that you'll always have an untouched version available to you. In Photoshop CS2, you can add a fiber texture similar to what you would see in the old fiber base photo papers. Use Filter>Render>Fibers. For this 8×10 sized print, I've set the Variance to 50 and the Strength to 4. Remember that Fibers take its color from the Foreground Color, which should be black (or deep gray for a more subtle effect). As I wrote in *Oil Tint,* if you're working with Photoshop 7 or earlier you will not have this option (Figure 1-135).

Step 3 After applying the Fibers filter, set the Opacity of the layer to 15% and its Blending Mode to Soft Light (Figure 1-136).

Step 4 Use Layer>Merge Down to create a new Layer 1. It will look something like this (Figure 1-137).

Figure 1-134

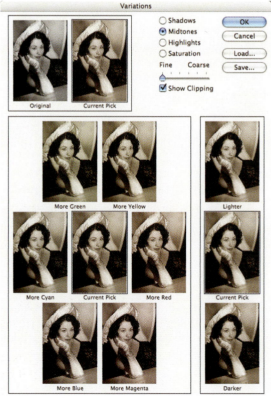

Figure 1-135

Figure 1-136

Step 5 Use Image>Adjustments>Variations to change the grayscale image to a sepia tone. With Midtones selected, and the Quality slider on Fine, click More Yellow twice and More Red three times (Figure 1-138).

Step 6 From the Layer menu above the Image window, create a new, transparent, layer with Layer>New>Layer. When the new dialog box opens, select Color for the Blending Mode (Figure 1-139).

Step 7 Grab the Eyedropper tool from the toolbox. Use it to select a flesh tone from the Swatches window, which will

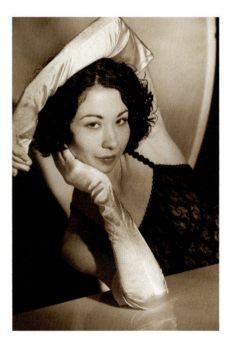

Figure 1-137

Figure 1-138

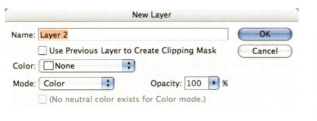

Figure 1-139

Figure 1-140

Figure 1-141

Figure 1-142

then show up as a new Foreground color. If the Swatches window is not visible, access it through Window>Swatches (Figure 1-140).

Step 8 Select a large brush, equal to about 1/3 of the width of the face. Set the brush opacity to 25%, then paint all flesh areas on the New Layer with a circular motion. Don't worry about staying in the lines. Add additional strokes to deepen the color in shadow areas and to add contour (Figure 1-141).

Step 9 Create a white Layer Mask and use a 75% hard-edged brush to clean up any coloring outside the lines, as well as eyes and mouth (Figure 1-142).

Step 10 Create another transparent layer from the upper Layer menu. From the Swatches menu, select a color for the eyes (I'll use a green) and paint them in with an appropriately sized soft-edged brush. Then find a nice lip color and paint them in. You may have to vary the number of strokes and the brush sizes to get it perfect (Figure 1-143).

Step 11 There should be a new layer created for every major color, so that any mistakes can be Layer Masked without affecting any previously applied colors. I'll create one other layer for

Figure 1-143

Figure 1-144

the gloves, and use the same color as I used for her lips to tie the colors together. For extra contour, I'll lightly dust her cheeks with the same color, just to add a little blush. Should you find that the colors are too strong for your taste, you can Image>Adjustments>Desaturate, but probably not more than 25%. I desaturated this image by 20% (Figure 1-144).

You may add other layers for additional colors or image areas. Hand-colored images were traditionally uncomplicated, so that visual emphasis would be on the subject. The sepia toned background and/or foreground were often left as is. If you add more layers, don't desaturate until you're finished.

Damage Free Dodge and Burn

Most Photoshop experts will tell you that it's destructive to use the Dodge and Burn tools found on the Toolbar because the tools actually alter the pixels they're used upon. Here's a foolproof way to dodge and burn that will be completely visible, but will not affect anything until the layers are merged together.

This technique goes far beyond any darkroom control you could ever have. You can dodge or burn very small, controlled, areas, and, of course, immediately undo any mistakes. Even when you're almost done, you can still fix any dodge or burn mistake, just by applying the opposite color to the area in question:

Step 1 Open your selected image (Figure 1-145).

Step 2 From the Menu Bar at the top of the screen select Layer>New>Layer (simply duplicating the layer will not work) (Figure 1-146).

Step 3 Set the Mode to Overlay, then check the new box that appears at the bottom: fill with Overlay-neutral color (50% gray). Click OK (Figure 1-147).

Step 4 Make sure the Foreground and Background colors are pure black and white (Figure 1-148).

Step 5 From the Brushes palette, select a soft-edge brush of a size appropriate to the area you need to dodge or burn. Then, from the Layers box, make the neutral color layer the active layer by selecting it (Figure 1-149).

Because the active layer is a neutral color, it has no effect on the color of the layer below. Consequently, applying any amount of white

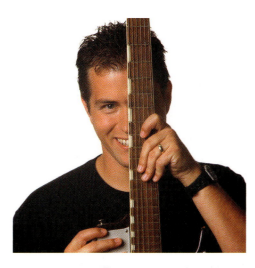

Figure 1-145

Figure 1-146

Figure 1-147

Figure 1-149

to the gray layer will appear to lighten the layer below, while applying any amount of black will darken the layer below.

Step 6 To burn, use black as the foreground color. Be certain the application opacity (found on top of the screen, just below the Menu bar), is quite low. Try 10% to start. Select Brush from the Toolbox, and brush to make the image darker where necessary. When we look at the layer by itself, it's easy to see the effect of the brush (Figure 1-150).

Figure 1-148

Step 7 To dodge, use white as the foreground color. The application opacity should be low to start; as before, start with 10%. Brush to dodge the image lighter where necessary. Now the layer shows both effects (Figure 1-151).

Figure 1-150 **Figure 1-151**

Step 8 Flatten the image when you're happy with the result (Figure 1-152).

Tip: If you need a softer edge to either the dodge or the burn, be sure the Brush tool is selected, then select the airbrush from the upper, secondary, menu. Set the airbrush opacity to 10% to begin (Figure 1-153).

Keyboard shortcut: You can toggle between the white and black foreground colors by typing "X".

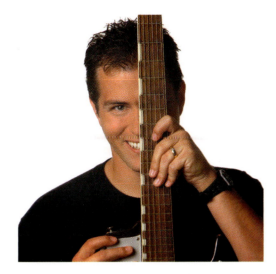

Figure 1-152

Figure 1-153

Section 2
Image Enhancements

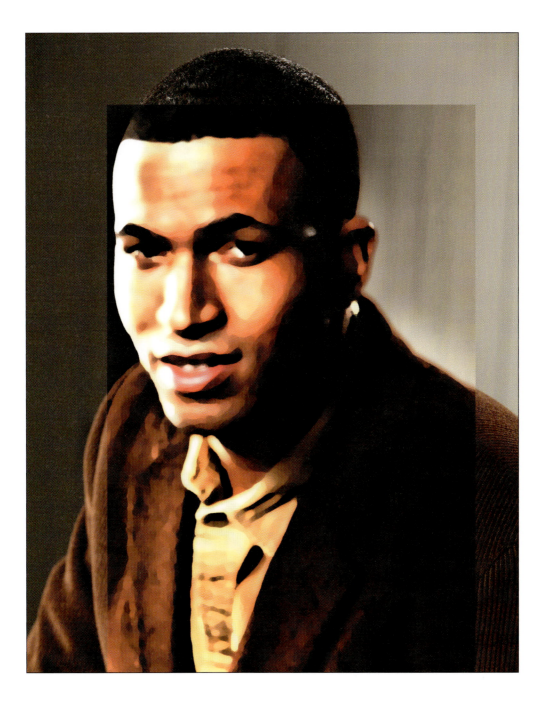

Surreal Backgrounds

I've used this trick for wedding, portrait, and editorial images whenever I've wanted to set the subject against a background that was realistic but different. Sometimes the effect is so subtle that viewers won't see it until it's pointed out to them, sometimes it just reinforces the composition. Either way, it's a simple technique that's easy to use:

Step 1 Open the selected image and duplicate the layer (Figure 2-1).

Step 2 Create a white Layer Mask from the Layers Palette (Figure 2-2).

Step 3 With black as the Foreground Color, paint a Layer Mask over the area(s) you wish to keep unaffected. I set the Hardness of my brush at 75%, but other images may dictate other settings. It's best to make the mask at this point because the image is easiest to see. Don't worry about thin, flyaway, hairs (Figure 2-3).

Figure 2-1

Figure 2-2

Figure 2-3

Step 4 At the Layers Palette, click on the image icon to the left of the mask icon, so as to work on the image and not the mask (Figure 2-4).

Figure 2-4

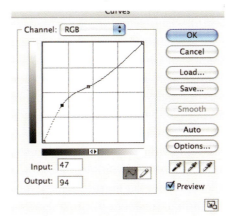
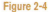

Figure 2-5

Step 5 A quick test of Step 6 convinced me the upper half of the background would be too dark, so I boosted the midtones in Curves. Most images do not show this tendency, but if yours does, here's a way to fix it (Figure 2-5).

Step 6 Apply Image>Adjustments>Posterize. I used a Levels setting of 8 for this image. In my experience, a range of 4–10 will yield the best images. You should look for a wide variety of distinct shapes (Figure 2-6).

Step 7 Go to Filter>Artistic>Cutout and apply the effect. I like to use the highest number of levels, 8, with this effect because it will retain the most information but still showcase the filter. Note that the Filter Window will show the effect applied to the entire image because it does not recognize the mask. Also note that Cutout requires a significant amount of RAM to run. It's possible that your machine may not have enough RAM for this effect. Sorry about that (Figure 2-7).

Step 8 Now apply Filter > Blur > Gaussian Blur to soften the lines. The chosen amount is strictly a

Figure 2-6

Figure 2-7

Gaussian Blur

OK

Cancel

☑ Preview

⊟ 25% ⊞

Radius: 26.0 pixels

Figure 2-8

Figure 2-9

matter of taste; I used a radius of 26 for this image (Figure 2-8).

Step 9 The final image is a nice mix of real and surreal (Figure 2-9).

HyperColor

No matter how wonderful your images are, there are always some that would benefit from a little extra zip. Portrait photographers will appreciate this technique because it's easy to do and easy to control.

The secret to this technique is the Posterize command found in the Image>Adjustments submenu. If you're old enough to remember the great rock and roll bands of the sixties, you probably also remember the bright, color delineated (and hard to read), posters that announced their concerts. A visual return to those heady days is just a mouse click away:

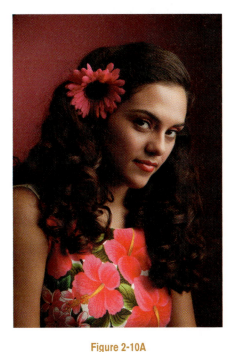

Step 1 Select an image and duplicate the layer (Figure 2-10A and Figure 2-10B).

Step 2 Select Image>Adjustments>Posterize. I usually select 3 or 4 levels, but you may like more or less. For this image, I'll use 4 because that level defines her cheek better than 3 (Figure 2-11).

Step 3 Saturate or desaturate the colors to your taste, using Image>Adjustments>Hue/Saturation (Figure 2-12).

Figure 2-10A

Figure 2-10B

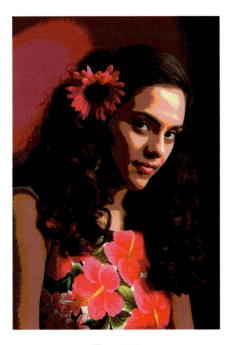

Figure 2-11

Figure 2-12

Figure 2-13

Step 4 From the Filter menu, select Gaussian Blur. Use the slider and set a level slightly higher that whatever it takes to blur the lines between the colors (Figure 2-13).

Step 5 With the Blending Mode set at Normal, use either the Master Opacity or Fill Opacity slider until you like what you see (Figure 2-14).

Step 6 If you need additional detail, perhaps in the face, create a white layer mask by selecting it from the Layers menu. Get a soft brush from the Toolbar, set the opacity to 30% and paint over the mask with black to reveal the sharper detail of the layer below. The end result will still be soft, but it will retain enough of the effect to show the stronger color (Figure 2-15).

Step 7 Flatten and Save. The HyperColor technique will add significant visual interest to ordinary snapshots, too (Figure 2-16).

Figure 2-14

Figure 2-15

Figure 2-16

Glowing Accents

Simplicity in lighting is something every photographer should strive for, especially when working with people, as they tend to get bored when a session doesn't move along smoothly. Time is often a factor, as well. If you've hired a model, even though you may be working with client money. You have a responsibility to get the job done as quickly as possible.

I will often structure a shoot with simplicity in mind, knowing the minor deficiencies that result can be remedied, even improved upon, with some creative Photoshop post-production. Bear in mind that any such fudging is within the confines of digital exposure latitude; although I may mess with the light:shadow ratio for any other accent, my key light (the light that all other lights or image areas are metered against) is always properly metered and exposed.

This image was lit with only one light. My model was positioned close enough to the background that light from the 18-in. reflector would spill onto it as well as a white fill card placed at camera left. I could have put another light at camera left, to accent her face even more, but I felt the subtlety of a one light scenario would be more mysterious, especially after some Photoshop work. Besides, my makeup artist provided a pretty nifty hat, and I wanted to make the most of it.

I moved a large white foamcore board into camera left, to bounce some light onto her face. Even though the board was clean and new, the bounce was almost 1½ stops darker than the key, and looked a little flat because of the size of the bounce card:

Step 1 I didn't want to change anything about the hat, so I began, on a duplicate layer, by freehand drawing, with the Lasso tool, an outline around the area I wanted to change. When done, I used Select>Feather>20 pixels to soften the edge (Figure 2-17).

Step 2 A rarely used filter, Filter>Distort>Diffuse Glow, will produce an interesting glow in highlights (no matter how flat they might be). Note that Diffuse Glow uses the Background color to produce the effect, which means you can vary the glow by changing the Background color, say to a flesh color highlight, for a different effect. For this image, I'm using pure white because I want more color contrast. (As always, I encourage you to try other settings than what you see in my sample.)

The Diffuse Glow filter can add its own grain, which I didn't want because the filter would only add the grain to the selection, so I set the Graininess slider to 0. The two remaining sliders, Glow Amount and

Figure 2-17

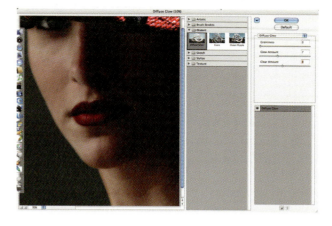

Figure 2-18

Clear Amount were set to 7 and 9, respectively (Figure 2-18).

Step 3 The Lasso selection is still in place, so we'll use it to tweak the brightness of that selection with Curves. Use Image>Adjustments>Curves or the keyboard shortcuts of Command-M or Control-M. Set your cursor right on dead center, click it and hold it down while moving to the left. You can watch the selection change as you change position. Just release the button when you're happy (Figure 2-19).

Step 4 Flatten and Save. The final result is quite lovely, with a quality that is both subtle and unusual (Figure 2-20).

You can also use this beautiful technique to carry the diffused glow *into* your image instead of out from it. Here's how:

Step 1 I started with an image of a model that had been shot against a backlit white Plexiglas® background. If you'd like more details of how to set up this lighting, sign up at ShootSmarter.com, a free digital info site. Once you're registered, just copy this link into your Browser's URL address window: http://www.shootsmarter. com/infocenter/cg015.html (Figure 2-21).

Step 2 Because there are many shades of white, I used the Eyedropper tool to sample a white close to her skin (Figure 2-22).

Step 3 For this picture, I wanted to take advantage of

Figure 2-19

Figure 2-20

Figure 2-21

Figure 2-22

Figure 2-23

Diffuse Glow's potential grain, while spreading the glow more than the previous example. The Graininess slider was set to 4, Glow Amount was 10, and Clear Amount was set at 12. This detail image shows how effective this trick can be for many images including those aimed at advertising or art. If you're a wedding photographer, try this on a silhouette shot of a just-married couple kissing in the doorway of the church (Figure 2-23).

Porcelain Skin

If I were to send this image to my client, as you see it here, there would be the devil to pay. Granted, my model is lovely and nicely posed, but the shot is underexposed and flat, with no life of its own.

I don't advocate either underexposure or overexposure unless you do it deliberately and know what you're going to do with the final result. Digital systems do not have the exposure latitude that film does, and light meters should be used now more than ever. But, even though this shot can never look normal, it was never meant to, and yet will be a stunning addition to this model's portfolio (Figure 2-24).

This will work just as nicely with a perfectly exposed image:

Figure 2-24

Step 1 Use Image>Mode>16 Bits/Channel to give the image more information, then begin by adjusting the Histogram. You can see how tonally flat this image is by the lack of full blacks. The spike on the far right is from the white background, and is quite a ways away from the skin tone highlights. I've pulled both sliders in as far as possible without blocking up or blowing out detail (Figure 2-25).

Step 2 There are some areas that could use dodging and burning. I'll create a layer for that purpose (see Foolproof Dodge and Burn), then clean up her eyes and bring out her iris color. Her undereyes need a little work, and I'll also soften the nasolabial fold between her nose and mouth. The only burning I need to do on this will be to add emphasis to her lower eyelashes. After the two layers were merged a small vein in her eye was cloned out (Figures 2-26 and 2-27).

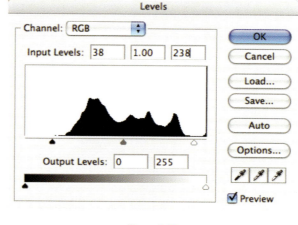

Figure 2-25

Step 3 I want to bring the contrast up in her face, to give her that contrasty, overly lit look that's so popular. I also want to darken the color of her hair and put more saturation into her lips and eyes, so I'll duplicate the layer, then set the Blending Mode of Layer 1 to Multiply. Perhaps

Figure 2-26

Figure 2-27

you noticed there is some flare from behind her, which softens the darks in her ribbon and hair. Using this Blending Mode to add density will eliminate that problem (Figures 2-28 and 2-29).

Step 4 Duplicate Layer 1, which will produce Layer 1 Copy, and set the Blending Mode to Screen. To retain the dark hair and ribbon, I'll create a white Layer Mask and paint it with black to reveal the darker color of the previous layer (Figure 2-30).

Step 5 So I can see exactly where I'm painting the mask, I'll hold down the Shift and Option keys while selecting the white mask icon from the Layers window. The brush strokes are represented by a red equivalent, and it's easy to see if I miss anything. Too get even coverage with a slightly soft edge, I set the Brush hardness to 75% (Figure 2-31).

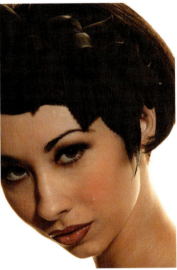

Figure 2-28

Figure 2-29

Figure 2-30

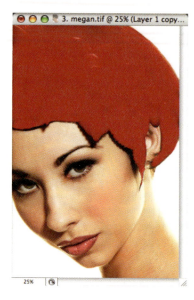

Figure 2-31

Figure 2-32

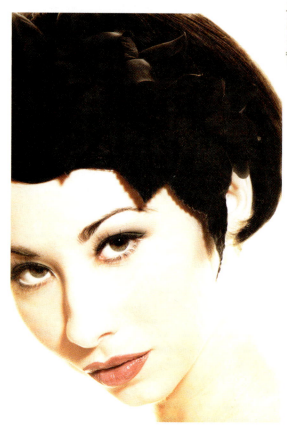

Figure 2-33

Step 6 Duplicate the working layer again, with the Blending Mode still set to Screen. Using Screen increases the exposure of each subsequent layer by 1/2 just like a camera's aperture. To get the effect I want, I'll duplicate the Screen layer 4 more times (your image may demand more or less) (Figure 2-32).

Step 7 To get a little more lip and eye color, I'll begin with Layer 1 Copy 5, click on the mask icon, and paint black on her irises and lips, repeating the exercise through layers 4 and 3, which will produce a soft blend, since the paint is different on each mask. The final image is sensual, mysterious, and gorgeous. Don't forget to Flatten and Save (Figure 2-33).

High Pass Sharpening

This little trick is so good I wish I'd invented it myself. I've seen it referenced many times in books and magazines, and it frequently turns up when someone asks for sharpening advice on Internet Photoshop discussion groups. The beauty of it is that you can vary the level of sharpening by varying the opacity level of its layer and it will not damage the pixels or create artifacts that affect the integrity of your image. See High Pass Soft Focus for a valuable variation.

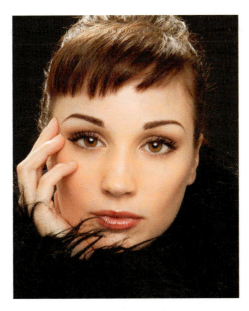

Figure 2-34

If you look carefully at my sample image, you'll notice that I missed perfect focus slightly. Either she moved or I did (and it was probably me), which put the point of focus on her temple rather than her eyes:

Step 1 Open the selected image and make a duplicate layer (Figure 2-34).

Step 2 Select Filter > Other > High Pass. I've generally been pleased when starting at a setting of 10 pixels. Your new layer will look pretty funky (Figure 2-35).

Step 3 Change the new layer's Blending Mode to Overlay (also try Soft Light) and change the layer's opacity until you're happy with the result. Many prefer an opacity of 30–40% but that's only a point of reference (Figure 2-36).

Figure 2-35

Figure 2-36

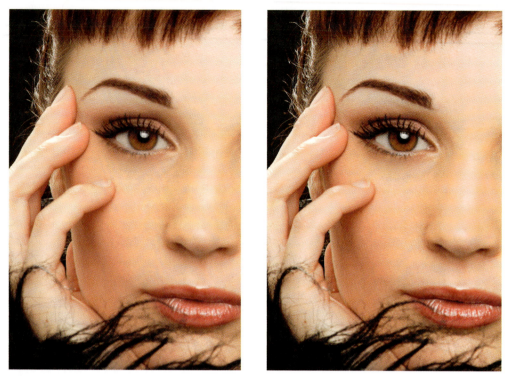

Figure 2-37 **Figure 2-38**

The difference is subtle but quite amazing. Before (Figure 2-37) and after (Figure 2-38).

High Pass Soft Focus

As far as subtle softening is concerned, this technique is hard to beat. It's variable by either changing the Opacity or Blending Mode. It's also a simple twist of the High Pass Sharpening technique noted elsewhere in this book:

Step 1 Begin by opening the selected image and duplicating the layer (Figure 2-39).

Step 2 Select Filter>Other>High Pass and set the pixel radius at 10 to start. You should certainly experiment with other radii, as higher numbers will increase the amount of glow without appreciably increasing the amount of blur (Figure 2-40).

Step 3 Change the new layer's Blending Mode to Soft Light (you might also try Overlay) (Figure 2-41).

Step 4 With the new layer selected, Image>Adjustments>Invert the layer to apply the softening. The end result, at a 10-pixel radius, is reminiscent of a Softar One, a commercial glass filter used with film cameras (Figure 2-42).

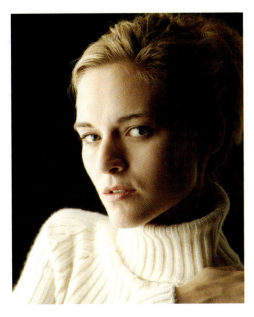

Figure 2-39

At a radius of 70 pixels, the glow around the subject is similar to what one would get

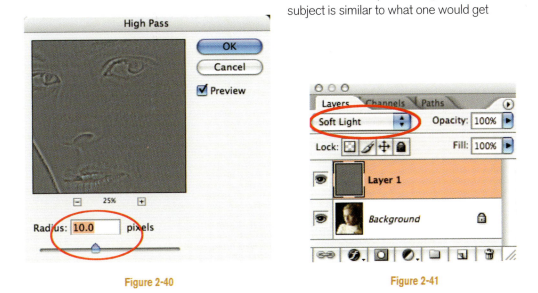

Figure 2-40 **Figure 2-41**

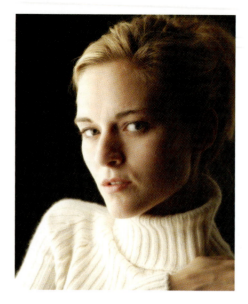

Figure 2-42

Figure 2-43

with a Softar 3 filter, but without the loss of sharpness expected from such a strong diffuser (Figure 2-43).

Overexposure Rescue

If there is any one great problem with digital photography it's that digital media has nowhere near the exposure latitude of film, especially on the high end. Wedding and Event photographers, who traditionally shot color negative film, rarely even noticed if their images were a stop or two overexposed because the problem was easily dealt with in the darkroom.

Not so with digital, where you're stuck with an overexposure limit of 1/3 stop. Granted, you can frequently save images that are lighter than that by adjusting the midtones in Levels, but the images will not look "normal"; backgrounds will darken, contrast will increase and detail will be lost while the brightest areas will show only minor changes. The potential problems of digital overexposure are compounded by the strobes themselves. Digital imagery does not respond well to specular light, so small on-camera or off-camera strobes should be used with a modifier like a bounce card, diffuser cap, or softbox to soften the light by broadening the source.

Okay, lecture's over. Mistakes happen and must be dealt with. Here's a quick fix that will add density and proper color to everything that shows any density at all, even bright whites, while allowing you to also make adjustments to the background. Bear in mind that nothing will put detail back into an area that has none to begin with.

We need to determine, as closely as possible, what a proper exposure would be. In this image, the most important elements are their faces:

Step 1 Open the image and duplicate the layer. Aside from the specular highlight in the man's glasses, the brightest spot in the picture is the tablecloth next to the drink in the center of the image. A quick look at the Info window says that there are even some small parts of that area with no detail at all. Unfortunately, we cannot put detail back in where it doesn't exist (Figure 2-44).

Figure 2-44

Step 2 Set the Blending Mode of the duplicate layer to Multiply. Multiply acts like two identical color slides sandwiched together; all tones, densities, and colors become uniformly darker (Figure 2-45).

Step 3 Use the Layer Opacity slider to blend the two layers. The image now sports a more presentable tonal scale (Figure 2-46).

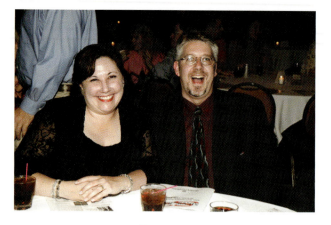

Figure 2-45

Step 4 You can take advantage of the lighter background of the original layer by creating a white Layer Mask and masking through to the original layer below. Masking will add more depth to the image by softening the natural fall off of the strobe. I set my Brush opacity at 35% and used a very soft edge.

A little extra work and the bright specular highlights in the man's glasses are history. Flatten and Save (Figure 2-47).

Figure 2-46

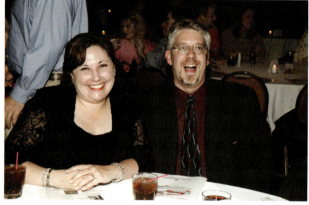

Figure 2-47

Hollywood Eyes

As a Photoshop professional who pays attention to what's being presented by individuals, organizations, and Web discussion groups, I've seen many tips and tricks discussed and dissected until even I, a certified Photoshop geek boy, am tired of them. Still, every once in a while a process comes along that is so simple and so elegant that it just blows my doors off.

Everyone has pretty much bought into the idea that movie stars are larger than life. A quick glance through the magazine rack at any supermarket will convince you that those California folk just look better, somehow, than the rest of us. Could it that that's the truth, or could it be that they just pay more for retouching (and get a lot more things retouched) than our clients ever would?

I suspect it's the latter.

Of all the subtleties Photoshop is capable of, this is one of the easiest and most significant.

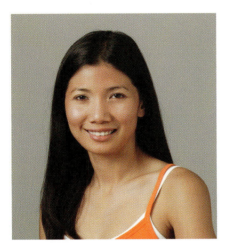

Figure 2-48

Figure 2-49

To say that everyone wants to look larger than life is an absolute truth, no matter what they may tell you. "Oh, I just need a quick shot for my mother," really means "I'd better look pretty darn good, pal, or you're out of luck, you know, for the money."

This is one of the little tricks that will help you get, you know, the money (Figure 2-48):

Step 1 With your selected image open, use the Lasso Tool and draw a circle around either eye. Draw around the entire orbit, and don't worry how rough it might be.

Step 2 Release the cursor, then hold down the Shift key (to add to the selection), and use the cursor to draw around the other eye (Figure 2-49).

Step 3 The easiest way to get the selection to another layer is to use the keyboard shortcut, Command-J for Mac, Control-J for PC. The keyboard shortcut will automatically place the selection in a new layer. Do not crop, move, or in any way change the dimensions of this layer (Figure 2-50).

Step 4 Deselect the background layer, so all that is visible is Layer 1 (Figure 2-51).

Step 5 Create a white Layer Mask for Layer 1 (Figure 2-52).

Step 6 With black as the Foreground color, choose a soft-edged brush and set the brush size to roughly the size of the subject's pupil. Paint to mask everything up to the subject's eyelids. There should

Figure 2-50

Figure 2-51

Figure 2-52

be no hard edges remaining (Figure 2-53).

Step 7 Go to Edit>Transform>Scale. A box will form around the eyes, and you'll also see a sub menu above the layer image box (Figure 2-54).

Step 8 You'll notice the Tool Options Bar appear above the layer image box; this is where we'll set the height and width of the transformation. I like to begin with a 3% increase in size. Select the "W" (width) box and change it to 103.0%. Do the same with the "H" (height) box. You'll notice that the eyes change size slightly when you tap the Return key to apply the changes (Figure 2-55).

Step 9 Reselect the bottom layer to see your changes. Flatten and Save, or redo the Scale of the eyes if you think your changes were too much or not enough (Figure 2-56).

Should you encounter a client who has one eye smaller than the other this technique may be the perfect fix for that condition.

Personally, I don't think you should increase the eye scale beyond 5%, but that's just me.

Figure 2-53

Figure 2-54

Figure 2-55

Figure 2-56

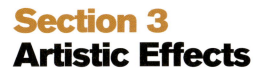

Section 3
Artistic Effects

Perfect Litho

Back in those daredevil days before computers, when commercial lithographic printing was film based, orthochromatic films were created to render nothing more than 100% black and 100% clear. The total lack of middle tones made these films ideal to rephotograph type or, in the case of color images, reproduce them as black dots of varying sizes, one piece of film for each ink color; yellow, magenta, cyan, and key (black). This CMYK color space is still used today, of course, but is now created digitally.

The most popular ortho film was Kodalith, available in many sizes from full-plate sheets to 35 mm. Photographic artists frequently used Kodalith just for the effect, and portraits made with this film could be very dramatic. It had one drawback in that it was impossible to dodge or burn effectively. The portion of the image tonally represented was entirely dependent on the exposure.

Photoshop can easily duplicate the Kodalith effect through Image>Adjustments>Threshold. Like its film counterpart, Threshold affects only a small portion of the image. With a little Photoshop ingenuity we can easily deal with the problem.

At first, radio personality Ruth Koscielak required only a new headshot. It wasn't until after the shoot that she wondered if the image could be converted, in a creative way, into a one-color design for a T-shirt. Ruth liked the idea of a solid black outline image but didn't like the way Threshold represented her, as there was no slider position that looked delicate enough (Figure 3-1).

Figure 3-1

Figure 3-2

It occurred to me that this could readily be done in pieces, and with more control than I ever could have had in the darkroom. Here's how:

Step 1 Duplicate the image (not just the layer) and fill the duplicate with white, Normal at 100% (Figure 3-2).

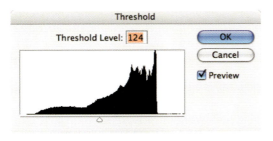

Figure 3-3

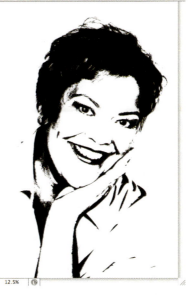

Figure 3-4

Step 2 Go back to the original and select Image>Adjustments>Threshold. Move the slider back and forth until you get a feel of how the final image might look, then look for any section that matches that look. Just a few passes and you'll know how the different parts of the image will need to look before they can be a complete picture.

Copy the entire image (Select>All, Edit>Copy) and paste it into the duplicate (Edit>Paste) (Figures 3-3 and 3-4).

Figure 3-5

Step 3 Select the Lasso Tool and freehand draw around the area you want to keep. Begin with her camera left eye, cheek, part of her nose and half of her mouth. When you've made your selection, go to Select>Inverse (to work on the area outside your selection), then Edit>Clear to eliminate everything except your selection. By clearing the image this way, you're guaranteed to place your selection in exactly the right place. If you simply copied your selection and pasted it into the duplicate, the selection would have been placed in the middle of the screen and difficult to line up (Figure 3-5).

Step 4 Go back to the original and return it to its original color form by clicking on the small color icon at the top of the History window (Figure 3-6).

Figure 3-6

Step 5 Select the Threshold Adjustment again, moving the slider to find another selection that matches the previous. Copy the entire image again, and paste it into the duplicate. Make your selection with the Lasso Tool, Select>Inverse, then Edit>Clear, just as before. This selection will

Figure 3-7

Figure 3-8

take the camera right eye and brow area (Figures 3-7 and 3-8).

Step 6 Repeat the Threshold process again. This time I've made an adjustment to get nicely textured hair (Figures 3-9 and 3-10).

Figure 3-9

Step 7 This process will be repeated until a complete image is built, one section at a time (Figures 3-11 and 3-12).

You will almost certainly have to clean up some of the lines, and it's very easy to do Layer Masks. With each layer, created a white Layer Mask and painted over whatever I felt did not contribute to the look my client wanted, an image more like a pen and ink sketch than a photograph, with black. When I added the back of the hand, for instance, the shadows found on her blouse looked way too chunky, so painted over the bad detail with a 75% hard-edge brush and put it back later, after an additional adjustment from the original image.

A different problem presented itself around her throat. The color value of her throat and blouse were very

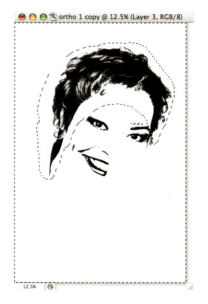

Figure 3-10

Figure 3-11

Figure 3-12

Figure 3-14

Figure 3-13

similar, and the line of her collar was impossible to achieve with just the Threshold tool (it would also have been impossible in the darkroom). After creating the shoulder line and the collar shadow, I added a neck image that was as bright as I could get it without losing the collar and neckline, created a Layer Mask, and painted over everything else (Figure 3-13).

Now that everything was in place, and knowing I would always to back to the original if I needed to redo something, the image was Flattened. The new Background Layer was duplicated and a white Layer Mask created, which allowed me to paint over everything, not just detail on a specific layer. Small details, like her eyes, the thickness of her palm, and miscellaneous artifacts on her face, arm, and blouse, were cleaned up.

There were also a few areas where no detail existed but had to be created; her camera right shoulder is a good example. The image was fading out there; there wasn't a threshold level that held the detail without blocking up around it. Still, it needed to have some detail to complete the illusion. I used a small textured brush so the line wouldn't be perfectly formed, and solid black color to draw the lines I needed. I also used the same brush to connect the lines of her collar.

The final printed T-shirt worked out beautifully, showing the simple beauty of this process and the charming personality of my client (Figure 3-14).

For even more variety, try applying some of Photoshop's filters to your final image. In fact, try the odd ones like Filter>Distort>Ocean Ripple or Filter>Distort>Glass.

Linoleum Block

You may remember doing this as a youngster in art class. After gouging out a design on a square of linoleum, you inked the surface, then placed a piece of paper on it and rolled over it with a brayer. When the paper was peeled off, the non-inked areas left a reversed version of your design. Success depended on how good you were with the chiseling tools (I was not).

This technique does exactly the same thing, but without the mess or sliced fingers:

Step 1 Open the selected image and duplicate the layer (Figure 3-15).

Step 2 Go to Filter> Blur>Smart Blur. Smart Blur will retain the sharp lines that define an image but blur the information in between. Set the Radius at 3.0 and Threshold at 25. I've generally been happy with a Quality setting of Low. Mode should be Normal. Should you decide you need more softening, simply use the filter a second time at the same settings (Figure 3-16).

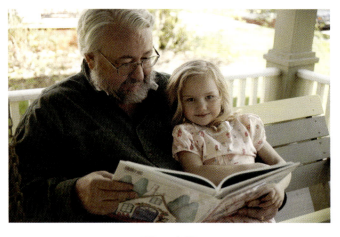

Figure 3-15

Step 3 Filter>Sketch>Photocopy will change your image to resemble something done on a very bad copy machine. That's fine. The image needs to be broken down to something very basic and rather sloppy. I prefer lines that are distinct but not too fat, and I also want minimal detail in fleshy areas, so I've set the Detail at 6 and Darkness right in the middle at 25. Note that Photocopy will use the Foreground color, whatever it may be. I used black, but could have used any other color (Figure 3-17).

Step 4 To finish the illusion, use Filter> Artistic>Cutout. I encourage you to play with the sliders because you can dramatically change the look of the image just by moving them around (Figure 3-18).

Figure 3-16

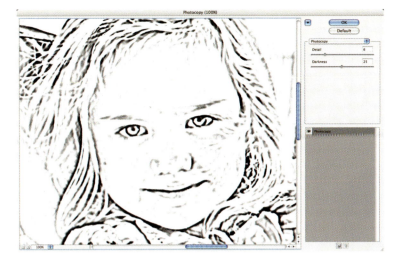

Figure 3-17

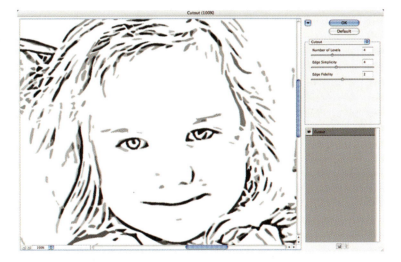

Figure 3-18

Step 5 It's interesting that the whites in these images are not pure. My guess is that it's built into the filter to make the pictures look a little dingy, like most photocopies (Figure 3-19).

To get to a pure white just call up the Levels box and select the clear eyedropper from the selection of three in the lower right. If you've never used this feature, the three eyedroppers represent black, middle gray, and white. The white eyedropper will turn any color value (and everything above it) to pure white, so, with that dropper selected, move the cursor onto any white area and click. All pixels at that color value and above will immediately lose all color information (Figure 3-20).

Figure 3-19

Figure 3-20

Step 6 To replicate the look you got as a kid, use Image>Adjustments>Invert (Figure 3-21).

Step 7 To add a trace of color, change the Blending Mode of the Cutout layer to Hard Light (Figure 3-22).

Even snapshots look very artsy with this technique. Could this be a profit center for your studio?

Figure 3-21

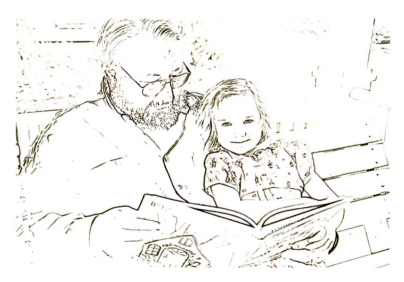

Figure 3-22

Scratchboard

When you were a child, chances are your art teacher had you cover a page with random crayon colors, then cover those colors with black. You drew by scratching through the black with a pointed stylus, until your design was revealed in a mélange of color.

This Photoshop technique is reminiscent of that scratchboard exercise and is quite entrancing to look at. However, it is not a technique for the patience impaired. My advice is to try this in front of a television, watching something lengthy:

Step 1 Begin by duplicating the layer (Figure 3-23).

Step 2 Using the Eyedropper tool, select any interesting color to begin. For this image, I'll start with her lip color (Figure 3-24).

Step 3 Fill the duplicate layer with the selected color with Edit>Fill. Fill at 100%, Blending Mode Normal. Be sure to select Foreground Color from the Contents submenu (Figure 3-25).

Step 4 Create a white Layer Mask, and black as the Foreground Color, then a small hard-edged brush. It may take a little experimentation to find a size you like. My camera produces 31 MB images, and I like the default 9-pixel brush for most of these pictures. Smaller files may dictate a smaller brush, which you can make just by changing the Master Diameter (Figure 3-26).

Step 5 Using rapid, random strokes, begin erasing through the

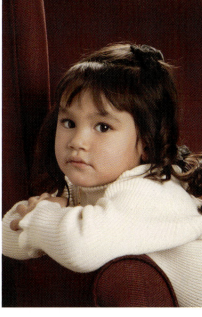

Figure 3-23

Figure 3-24

Figure 3-25

Figure 3-26

filled layer, revealing the untouched image below. Continue until you've erased around 90% of the fill color (Figure 3-27).

Step 6 Duplicate the Background layer and move it to the top of the queue (Figure 3-28).

Figure 3-27

Step 7 Use the Eyedropper tool to select another color. For this example I'll use a deeper color from the chair. Fill the new layer as in Step 3 (Figure 3-29).

Step 8 Create another white Layer Mask and paint over as before. The final image will start to reveal itself (Figure 3-30).

Figure 3-28

Figure 3-29

Figure 3-30

Step 9 Duplicate the Background layer again, and move it to the top (Figure 3-31).

Step 10 Select another color from the original. This time I've selected a medium hair color (Figure 3-32).

Step 11 Fill and paint through a white Layer Mask as before (Figure 3-33).

For variety and interest, a complementary color might be nice. A complimentary color is a given color's opposite, and, in Photoshop is very easy to acquire.

Step 12 Duplicate the Background layer and move it to the top. Use Image>Adjustments> Invert to reverse all colors to their negative equivalents. Sample any color with the Eyedropper (Figure 3-34).

Figure 3-31

Figure 3-32

Figure 3-33

Figure 3-34

Step 13 Undo the Invert command. Create and paint through another white Layer Mask as before (Figure 3-35).

Step 14 Make as many additional color layers as you wish. There are two more steps to fulfilling the illusion. First, duplicate the Background layer and move it to the top of the queue, then fill it with black (Figure 3-36).

Step 15 Create another white Layer Mask and paint almost all of the white out. This layer is just to reinforce an illusion of white paper. Paint through 100% of it in the center, leave just a little around the edges (Figure 3-37).

Step 16 Almost done. Duplicate the Background Layer and use Filter>Artistic>Cutout. Start with Number of Levels at 4, Edge Simplicity at 4, and Edge Fidelity at 2 (Figure 3-38).

Step 17 Duplicate the Cutout Layer (Background Copy 6) again and set the Blending Mode to Overlay. Duplicate once more for more contrast. Flatten and Save (Figure 3-39).

Figure 3-35

Figure 3-36

Figure 3-37

Figure 3-38

Figure 3-39

If you'd like to make the image a little more painterly, start with the flattened image and duplicate the layer. Apply Filter>Distort> Glass. Start with a Distortion setting of 20, Smoothness 8, Frosted glass at a scale of 70%. The settings I've used are just starting points for you; you'll need to play to find your own favorites.

For the final effect, Desaturate the layer and change the Blending Mode to Soft Light (Figure 3-40).

Figure 3-40

Rough Pencil Sketch

Try this technique, then print it on a warm tone matte paper. If you can find a paper with a rough texture, so much the better, as it will accent the look of the effect:

Step 1 Duplicate the layer, just for insurance (Figure 3-41).

Step 2 Select the Red channel (Figure 3-42).

Step 3 Select Filter>Artistic>Rough Pastels. After working the sliders, I determined these settings worked best for this image: Stroke Length at 4,

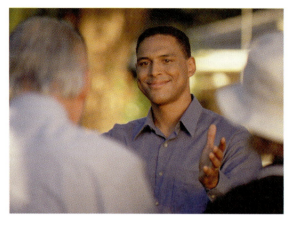

Figure 3-41

Figure 3-42

Stroke Detail to 19, Scaling was limited to 50%, with Relief at 25. You must specify a Texture to use this filter; I find Sandstone to be effective and the least intrusive, visually, but you might like another. The natural light in the image came from top right, so that's the Light direction I selected (Figure 3-43).

Step 4 Change the image to complete grayscale by using Image>Mode>Grayscale. The software will ask you if you want to Flatten; click OK. Also click OK when it asks you if you want to discard the other channels. This technique is a simple procedure and you can back up in the History Palette if you mess up (Figures 3-44 and 3-45).

Step 5 Now, add Filter>Texture>Grain>Speckle. Adding grain

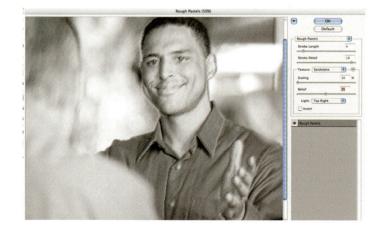

Figure 3-43

Figure 3-44

Figure 3-45

could increase the contrast, some of which is welcome, so I've set the Intensity of the effect to 0, and held the Contrast to 35. Some contrast is fine, but I don't want to give the impression that the image is pure black and white (Figure 3-46).

Step 6 If you'd like to give the impression that there are no pure whites showing through the image, as I did, first duplicate the layer, then select a light gray (I used DAD8D8). Fill the layer with the gray color at 100% with the Blending Mode at its default Normal setting. Use Filter>Artistic>Rough Pastels at the same settings as Step 2, to keep the texture consistent. I finally settled on an Opacity of 30%, with the Blending Mode of the new layer set to Multiply. Flatten and Save (Figure 3-47).

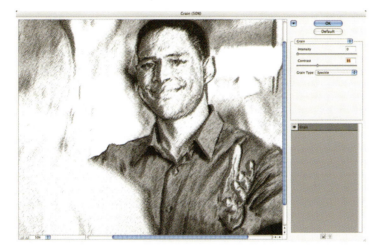

Figure 3-46

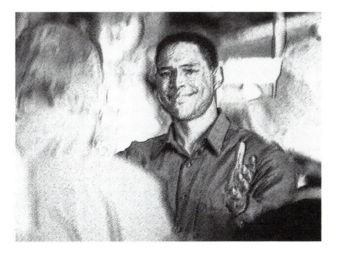

Figure 3-47

Charcoal/Pen Sketch

Simple and elegant, this technique yields beautiful, believable, results, especially when the image is printed on a flat paper such as watercolor. Piezography, in which the image is inkjet printed with numerous shades of black, is also extremely effective.

In my opinion, images made in this manner look very much like a charcoal sketch, but without any smudging:

Step 1 Open your selected image and Image> Duplicate (Figure 3-48).

Step 2 Use Image>Mode>Grayscale to convert the image (Figure 3-49).

Figure 3-48

Figure 3-49

Step 3 Reselect the original image. Switch from Layers to Channels and look at each channel individually. You'll want one that's relatively flat and with a tonal spread that doesn't look goofy. After looking at the three channels, I've decided to use the Green channel to begin (Figures 3-50–3-52).

Step 4 From the Filter menu, go to Filter>Artistic>Rough Pastels. As a starting point, set Stroke Length at 4, Stroke Detail at 19, Scaling to 50%, and Relief at 25. I prefer to use Sandstone for Texture because it's the least intrusive to my

Figure 3-50

Figure 3-51

Figure 3-52

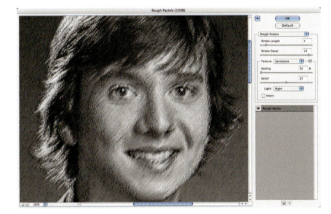

Figure 3-53

Figure 3-54

eye. Light should approximate the direction of the image's key light (Figure 3-53).

Step 5 Copy the image (Select>All, Edit>Copy) and paste it onto the grayscale copy (Edit>Paste) (Figure 3-54).

Step 6 The next step requires a little contrast. Go back to the original and return it to its first state by clicking on the image snapshot at the top of the History window. Select Channels, then Red Channel (because it is the most contrasty) (Figure 3-55).

Step 7 Apply Filter>Texture>Grain> Speckle. Try an Intensity of 70 and 0 for Contrast (Figure 3-56).

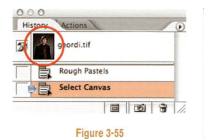

Figure 3-55

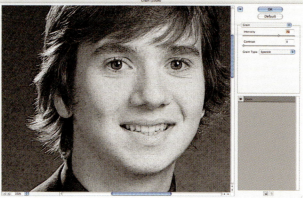

Figure 3-56

Figure 3-57

Step 8 As in Step 4, copy the layer and paste it onto the duplicate. Set the Blending Mode of this new layer to Soft Light (Figure 3-57).

You might also try the other Grain varieties for different looks. This shot utilized the Green channel and Soft grain (Figure 3-58).

Figure 3-58

Photocopy Sketch

Filter>Sketch>Photocopy is a very interesting filter. You'll notice as you go through the book that I've found many uses for it. It was designed to mimic the look of a bad copy machine, which it does very well, but it's also useful as a sketch tool (Figure 3-59):

Step 1 Photocopy draws its colors from the Foreground and Background colors, so be sure to set them before acquiring the filter. The Foreground color will form the outline, the Background color will fill everything else (Figure 3-60).

Step 2 We need to smooth out non-essential detail, as Photocopy will tend to accentuate small things, like facial pores. Duplicate the Layer and apply Filter>Blur>Smart Blur. Set Radius at 10, Threshold at 25, Low Quality, and Normal Mode (feel free to experiment with these settings) (Figure 3-61).

Step 3 Apply Filter>Sketch>Photocopy. Set the sliders to give you a decent outline, but not so dark that too many artifacts show up in areas that should be clean. After a little experimentation, I set the Detail slider to 8 and the Darkness slider to 35 (Figure 3-62).

Step 4 Use Levels to brighten the whites (which will eliminate some of the artifacts) and increase the darks. The histogram, which will look strange to begin with, will look even more odd when you're done (Figure 3-63).

Step 5 Exchange Foreground and Background colors and select a hard-edged brush to paint over any remaining artifacts (Figure 3-64).

Figure 3-59

Figure 3-60

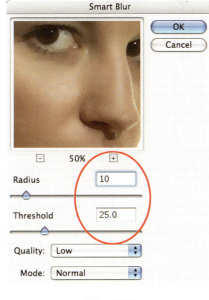

Figure 3-61

Figure 3-62

Step 6 Select Filter>Artistic>Rough Pastels to give the lines a more organic appearance. Set the sliders for a minimal effect; I set both Stroke Length and Stroke Detail to 2. I like Sandstone for the underlying texture, and I set Light to Top Left, to match the light direction in the image (Figure 3-65).

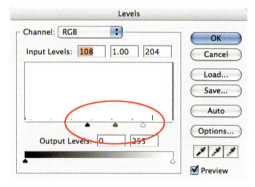

Figure 3-63

Figure 3-64

Figure 3-65

Figure 3-66

Step 7 Use the Clone tool to eliminate any remaining flaws, try other filters for additional effects, or Flatten and Save for a black and white sketch. If you'd like a little color, try setting the Blending Mode to Hard Light, Vivid Light (used here), or Hard Mix (Figure 3-66).

Grain Sketch

When you allow for the variations achievable through the Blending Mode and Opacity options, Photoshop's Filter range is enormous. Experimentation and an open mind will get you, and your clients, great images that will outlive us all.

While researching this book, I spent several hours just playing with the 10 options available under Filter>Texture>Grain. Each of the supplied grain effects is different, and some I like more than others. It occurred to me that the correct application of just a select few grain effects could create an image of unique grace and beauty:

Step 1 I'll begin by opening, and then duplicating, the selected image (not just the layer) (Figure 3-67).

Step 2 Fill the duplicate with white at 100%, Blending Mode "Normal". I do this because duplicating the image produces a new canvas exactly the same size as my original, which may not be a preset size like 8×10 or 5×7 (Figure 3-68).

Figure 3-67

Step 3 From the original, select "Channels", then select "Red". Red is usually the brightest channel and the brightest channel is usually my choice. Depending on the subject matter or the mood I want to create, though, I may choose another (Figure 3-69).

Step 4 From the Filter menu, select Texture>Grain>Speckle. Higher than normal contrast is useful, and for this image we'll set "Intensity" to "40" and "Contrast" to "90". You may need to

Figure 3-68

Figure 3-69

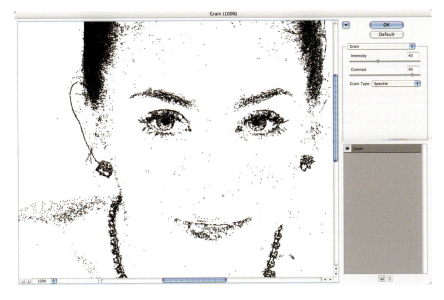

Figure 3-70

change these settings for your own images. When you're satisfied with the effect, apply the grain (Figure 3-70).

Step 5 Copy (Select>All, Edit>Copy) and Paste the image onto the white-filled duplicate (Edit>Paste). Speckle Grain is clumpy, so take a closer look at the image after you paste it in. There are parts of this one that could become problem areas such as her lips, some extra speckles on her face and the shadow line on her shoulder. The best way to get rid of or soften these artifacts is with the Clone Tool because a Layer Mask, or even the dreaded Eraser, will affect the density of the image. Find a large-area free of artifacts and clone from there. For this image I've cloned out the lines on her shoulders and lips as well as miscellaneous spots on her face (Figures 3-71 and 3-72).

Step 6 Go back to the original image and get it back to its original state by clicking on the little snapshot at the top of the History window (Figure 3-73).

Step 7 Select the Red (or your favorite) channel again. From the Filter menu, select Texture> Grain>Soft. Soft grain needs, I think, less contrast because it makes up a great deal of the image's form. That's just my opinion. You should try other

Figure 3-71

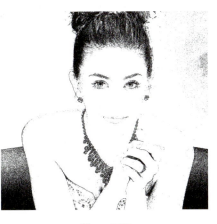

Figure 3-72

Figure 3-73

combinations and let the image tell you what it needs. For this image I'll set "Intensity" at "50" and "Contrast" to "50" (Figure 3-74).

Step 8 As in Step 5, Copy and Paste the Soft Grain image onto the duplicate, automatically creating a new layer. Set the Blending Mode of the new layer to "Dissolve", and the Opacity of the Blending Mode to 50% (Figure 3-75).

Step 9 Here's an optional step which may provide more defined edges. If you choose to use it be sure to check the image carefully for areas that need to be

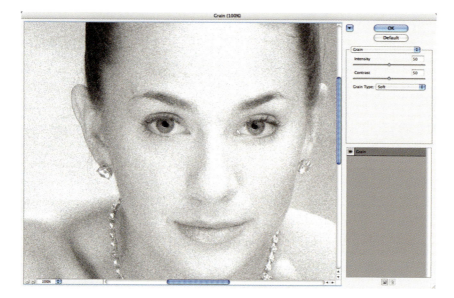

Figure 3-74

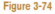

Figure 3-75

cloned out, as the effect seems to "chunk up" a bit over contoured areas such as a face.

Go back to the original image and its original state. Select your favorite channel (I used the Blue channel because I liked the flatter contrast) then apply Filter>Stylize>Find Edges. This filter creates form defining lines that may add visual depth to your Grain Sketch. After I decided to use this filter, I cloned from the white area (even though it's not pure white), and painted over, at 100%, most of the tones on her face and hairline (except for her eyes) as well as the extra density on her shoulders and jewelry. Paste this onto the duplicate and set the Blending Mode of this layer to Multiply or Darken. I used Multiply. Here's what the painted mask looked like (Figure 3-76).

Figure 3-76

Stop here and you'll have a lovely grayscale Grain Sketch. Note that it's still an RGB image, so if you want no color at all, change it via Mode> Grayscale (Figure 3-77).

There's more, of course. Go back to the original and its original state. Copy the full RGB image, then create a new layer by pasting it over the duplicate. Set the Blending Mode of this new layer to "Color". Adjust the Opacity slider as you wish, then Flatten and Save. Now you've got it all (Figure 3-78).

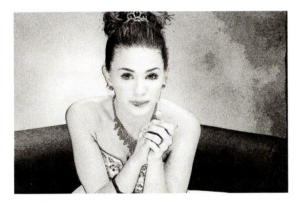

Figure 3-77

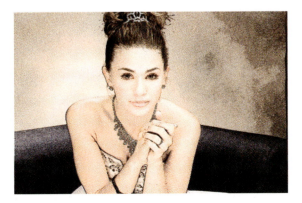

Figure 3-78

Grain Sketch is a beautiful effect when applied to fine art images. This image of a ballerina was done with exactly the same steps as the previous image except that I used the Green channel for Step 9 (Figures 3-79 and 3-80).

Figure 3-79

Figure 3-80

Watercolor Painting

Watercolor paint is a beautiful medium in high demand as fine art. Visit any art fair and you'll see watercolors in every size and of almost every subject.

If you've ever tried Photoshop's native Watercolor filter you may have been disappointed with the result. It just doesn't look right, no matter how you set the filter's parameters. My recipe is substantially more complicated, but not difficult, and will produce a much more believable result. When you master it, and perhaps add a twist of your own, you will have the basis for a product line for which you can receive higher fees and which will set you apart from your competition.

It took a long time to streamline this process, but it was worth it. Feedback from clients and peers has been very favorable.

Note that this technique will increase contrast. Depending on your images, you may be able to use that to your advantage.

Method one

Step 1 Open your image and duplicate the Layer two times (Figures 3-81 and 3-82). Make sure the top layer is selected.

Step 2 Apply the Palette Knife filter (Filter>Artistic>Palette Knife). Set Stroke Size to 25, Stroke Detail to 3, and Softness to 0 (Figure 3-83).

Step 3 Repeat the Palette Knife application (Figure 3-84).

Step 4 Let's make this top layer even more abstracted. Apply Filter> Artistic>Paint Daubs with the Brush Size at 8 and Sharpness at 0. Select Dark Rough from the Brush menu (Figure 3-85).

Figure 3-81

Figure 3-82

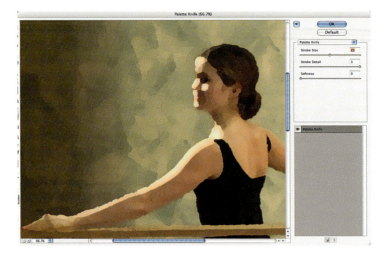

Figure 3-83

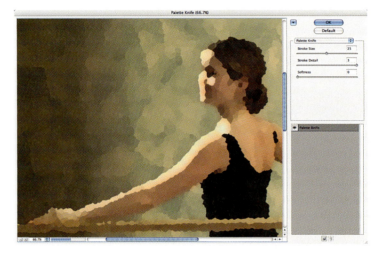

Figure 3-84

Figure 3-85

Figure 3-86

Step 5 Apply Filter>
Artistic>Cutout. This
particular filter crunches a
lot of numbers and uses
as much RAM as it can
get. It's possible that your
computer won't handle
this command but it's not
critical; it just adds more
atmosphere. I've found
that 4 Levels works best.
Also select 4 for Edge
Simplicity but only 2
for Edge Fidelity (Figure
3-86).

Step 6 Apply Filter>Blur>Gaussian Blur. Use a little
less than it would take to totally eliminate the lines between
the colors. For this image I'm using a pixel radius of 15.4
(Figure 3-87).

Step 7 Now apply Filter>Brush Strokes>Dark Strokes
with 5 for Balance and 0 for both Black and White
Intensities (Figure 3-88).

Step 8 Select the middle layer. Hide the top layer by
turning off the Layer Visibility icon on the left column
(Figure 3-89).

Step 9 To the middle layer, apply Filter> Artistic>
Watercolor with Brush Detail to 9 and Shadow Intensity
at 0. Texture should be the minimum, 1 (Figure 3-90).

Figure 3-87

Figure 3-88

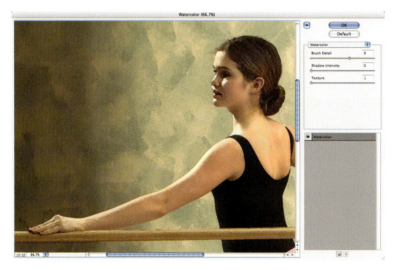

Figure 3-89

You may repeat the Watercolor filter application, if you wish, to get a deeper effect. Check the image carefully before clicking OK, as this filter can do nasty things to facial details.

Step 10 Reselect the top layer, click the Layer Visibility button and set the Opacity to ±25% (Figure 3-91).

Step 11 Select the middle layer. Change the Blending Mode to Overlay and the Opacity to (your taste will dictate) between 65% and 100% (Figure 3-92).

Step 12 The Overlay Mode adds contrast as well as color. I'll desaturate this layer 80% to get close to the original color while retaining a little of the warm color from the Blending Mode. Image>Adjustments>Hue/Saturation (Figure 3-93).

Figure 3-90

Figure 3-91

Figure 3-92

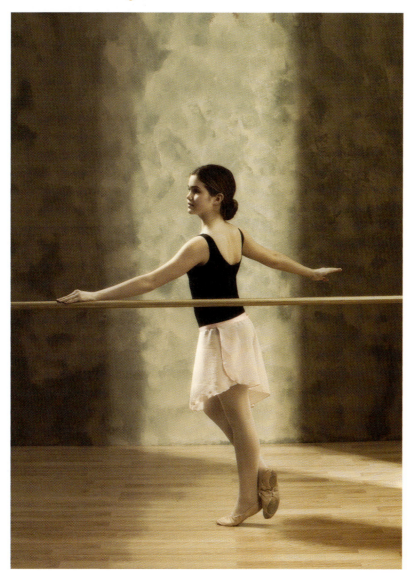

Figure 3-93

I know you're wondering why all those initial steps were necessary since their affects are not visible. The finished image now sports the appearance and texture of a finely detailed watercolor, largely due to the visual and color texture created in that top layer. If you do your own printing, be sure to output this to a quality watercolor paper (Figure 3-94).

Figure 3-94

Wet Watercolor

When watercolors are allowed to run together, wonderful things can happen to the image. Line and form can be abstracted, revealing an unexpected, yet emotional beauty, especially when the painting was made with broad strokes to minimize detail.

For an authentic look, print your images on a classic watercolor paper:

Step 1 Duplicate the layer (Figure 3-95).

Step 2 Select Filter>Artistic>Palette Knife. For this image, I've set the Stroke Size to 38, Stroke Detail to 3, and Softness to 10. Yes, you really do want it to look like this. Trust me (Figure 3-96).

Step 3 Filter>Noise>Median is next. I think I get the best results with a small adjustment, just enough to soften the lines, not enough to eliminate them (Figure 3-97).

Figure 3-95

Figure 3-96

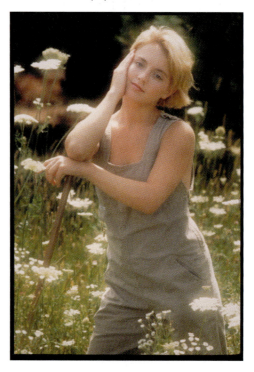

Figure 3-97

Step 4 Go back to the original layer and make another duplicate. Use Image> Adjustments>Desaturate to create a grayscale version, then duplicate the new grayscale l ayer. Select the duplicate grayscale layer and use Image> Adjustments>Invert to convert it to a negative (Figure 3-98).

Step 5 Hide the uppermost layer by clicking on the eye icon, to make the grayscale layer visible. Reselect the negative grayscale layer and change its Blending Mode to Color Dodge. The screen will change to white. If some black areas remain, that's okay (Figure 3-99).

Step 6 Go to Filter>Blur>Gaussian Blur. Set a fairly high number (I used a pixel radius of 70). A faint grayscale image will appear (Figure 3-100).

Step 7 Use Layer>Merge Down to merge the two grayscale layers together (Figure 3-101).

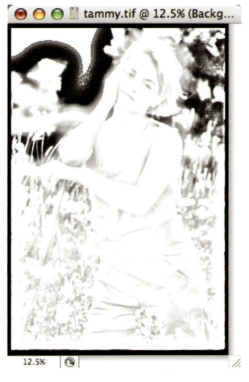

Figure 3-100

Figure 3-98

Figure 3-99

Figure 3-101

Figure 3-102

Step 8 Use the black slider in Levels to darken the gray. I increased the value to 100 for this image (Figure 3-102).

Step 9 (This is an optional step; some images love it, others don't. You decide.) Apply Filter> Artistic>Dry Brush to the grayscale layer. I set the Brush Size at 10, the Brush Detail at 10, and the Texture at 2, but you should experiment until you find another combination that suits your personal taste or esthetic (Figure 3-103).

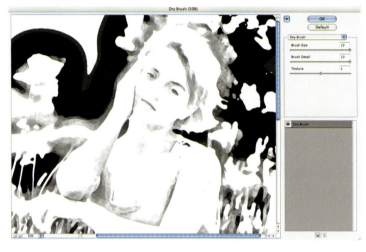

Figure 3-103

Figure 3-104

Step 10 Apply a small Gaussian Blur to the grayscale layer, no more than a 3-pixel radius (Figure 3-104).

Step 11 Select the merged grayscale layer and drag it to the top of the queue, and set its Blending Mode to Overlay. Then reselect the previously hidden layer (Figure 3-105).

Figure 3-105

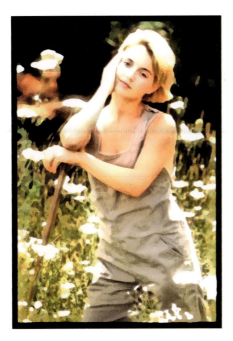

Step 12 Almost done. Select the middle layer, the color layer to which the effects have been applied, and duplicate it. Set its Blending Mode to Multiply. Use the Opacity slider to lighten the image until you like it. Flatten and Save (Figure 3-106).

You can get the look of a much broader stroke just by making one small change. At Step 4, instead of duplicating the untouched bottom layer, use the working layer instead. After you make the two-grayscale layers, the resulting outline will be much rougher (Figures 3-107 and 3-108).

Figure 3-106

Figure 3-107

Figure 3-108

Silkscreen Prints

Whether done for art or commerce, few mechanical techniques rival the simple beauty of a nicely executed silkscreen print. Although the style may have hit its peak in the 1970s, when most advertising for psychedelic rock and roll bands originated with silkscreened images (and it seemed one had to be under the influence of *something* to decipher the headline and copy), any walk through an art fair will find a number of artists printing excellent material and getting good prices.

To get their final product, screen artists had to either hand-cut masks or burn them through ortho film stock (using very hot lights producing high ultraviolet output) onto a screen. When all was ready, the artists pulled ink over the screen with a squeegee, coating the substrate underneath.

A new screen mask had to be produced for every color used in the process.

It was, and remains, a time-consuming task, prone to registration errors and quite messy. Depending on the number of colors and the intricacy of the design, it would not be unusual for an artist doing hand-pulled prints to ruin the majority of a run.

Photoshop, as you can imagine, easily eliminates the madness of silkscreen style designs. For those of you who may wish to produce traditional screen prints, Photoshop can be utilized to produce perfect masks for printing onto conventional materials.

Screen printers were limited by the number of ink colors on hand, and the number of colors that could be mixed from them. Photoshop can work with any of the millions of colors available through the Color Picker, and you should freely experiment with them.

Speaking of color, I've found an easy way to work with color schemes that are perfectly matched and very contemporary, by simply scanning decorator color swatches from the paint department of my local hardware store. Chosen by professional colorists and designers, these swatches are more harmonic than any group of colors I would pick out on my own, and a lot easier to arrive at (Figure 3-109):

Step 1 Begin by opening the selected image and duplicating the layer (Figure 3-110).

Step 2 Use the Magic Wand to select the area for the first mask, his shirt. Set the Tolerance higher than usual (I used 50 pixels) and be certain to check Contiguous to avoid including areas

Figure 3-109

Figure 3-110

of similar tone in unwanted portions of the image (Figure 3-111).

Step 3 It's rare when one click of the Magic Wand will get everything you want. To add to the selection, hold down the Shift key while clicking on more areas. When you have everything you want, use Command-J (Control-J) to copy the selection to a new layer (Figure 3-112).

Step 4 Picking up some unwanted detail is unavoidable. This is one time the use of the Eraser is recommended because the areas in question are small (and easy to Undo) and we want a totally transparent background. Sometimes these details are quite small and you have to look for them (Figure 3-113).

Step 5 Select the Image portion of the layer and use the Clone tool or Paintbrush to fix any holes in the image that were not selected but that you want to keep (Figure 3-114).

Figure 3-111

Figure 3-112

Figure 3-113

Figure 3-114

Step 6 Using the Eyedropper Tool, get the first color from the previously scanned swatch or from the Color Picker, so that it shows in the Foreground Color window. This is the color we'll use for the shirt (Figure 3-115).

Step 7 Switch to the Magic Wand, select the transparent area of the working layer, then Select> Grow to be certain all relevant pixels have been chosen. When you're satisfied with the selection use Select>Inverse to transfer the selection to the shirt (Figure 3-116).

Step 8 Change the color with Edit>Fill. Select Foreground Color (the color chosen in Step 6), set the Blending Mode to Normal, 100% Opacity. Do not check Preserve Transparency (Figure 3-117).

Figure 3-115

Step 9 With the first color in place, duplicate Layer 1 (be sure to check for the "marching ants" that indicate your previous

Figure 3-116

selection is still in force. Deselect, if that's the case), before making another selection. Because I'll be working with the face, and not a more solid shape, I'll take a different approach. First, reset the foreground and background colors. The filter that will be used, Torn Edges, creates its effect using those colors. Set the Foreground Color to Black. Select one of the decorator colors for the Background Color (Figure 3-118).

Step 10 Select Filter>Sketch>Torn Edges. My settings, Image Balance 24, Smoothness 8, and Contrast 9, are completely arbitrary. Move the sliders around until you're happy (Figures 3-119 and 3-120).

Step 11 To get a perfect, sharply edged black image, use Image>Adjustments>Threshold. The default slider position is where you want to be. Click OK (Figure 3-121).

Step 12 Select another patch from the swatch and create a new Foreground Color. Deselect "Contiguous", then get the Magic Wand and click on the black area of the image. Use Select> Grow to enlarge the selection, then fill the selection with the new color as in Step 7 (Figure 3-122).

Figure 3-118

Figure 3-117

Figure 3-119

Figure 3-120

Figure 3-121

Figure 3-122

Figure 3-123

Step 13 From the swatch, select a color for the face and hand (Figure 3-123).

Step 14 Duplicate the working layer (Layer 1). Use the Magic Wand (Contiguous) and Shift-Click to select the uncolored face, hand, and neck areas. Select>Grow to make sure as much as possible is caught, then fill with the new color. It may not be obvious with the small reproduction here, but I did not fill the catchlight in his eye (Figure 3-124).

Step 15 After adding the color, deselect the marching ants. Duplicate the working layer, then fill the last clear section with the remaining color. Reselect all layers, then flatten them and use the Clone tool to fix any problems. The end result looks remarkably like a mechanically produced silkscreen print (Figure 3-125).

Figure 3-124

Figure 3-125

Step 16 Here's an optional step: If an image would benefit from an outline, go back to the original Background layer and duplicate it. Create an outline at Filter>Stylize>Find Edges. Desaturate the layer, then adjust Levels to a very narrow range, eliminating almost all of the lines. Move this layer to the top of the queue and set the layer's Blending Mode to Multiply. Adjust the Opacity slider until you like the effect, then Flatten and Save. Any obnoxious details can be fixed by painting on the layer with white (Figure 3-126).

Here's an additional tip: You can vary the color or intensity of any layer by changing its Blending Mode before flattening.

 Experiment with other filters to make the layers. Some will change the edge, some may change the interior texture; all have possibilities.

Figure 3-126

Impressionism

Perhaps the ultimate painterly effect, Impressionism uses daubs of color to represent a visual impression of a subject without attention to detail. Impressionism makes for very dramatic portraits as well as beautiful scenics and still lifes.

After you get familiar with this technique, feel free to play with different filters and blending modes. I noticed a number of interesting changes as I was working toward a final formula (I've noted a few of them in the text) and am certain there are others that you can use to make your transformations more personal.

The Photoshop Impressionist technique involves more steps than others, but is well worth the time. Try printing your images on a fine art canvas:

Step 1 Open an image and duplicate the layer (Figure 3-127).

Step 2 Step 4 may not completely cover the image, and any areas not covered will pick up whatever background color is selected. To make sure it's a compatible color, use the Color Picker on the image. I like a dark flesh tone or mid hair color, so that if the color shows up other than on the subject it's still tied in to the image. For this

Figure 3-127

image, I chose her hair color from the camera right side (Figure 3-128).

Step 3 From the Layers window, select Channels, then select the Red channel (Figure 3-129).

Step 4 Go to Filter>Pixelate>Pointillize and select a Cell Size value of 10 for the first application. The slider may not hit an exact 10; 9 or 11 are fine, or you can just type 10 in the Cell Size window (Figure 3-130).

Figure 3-128

Figure 3-129

Figure 3-130

Step 5 Go back to the Channels window and select the Green channel. Return to Filter> Pixelate>Pointillize and set a Cell Size of 15 (Figures 3-131 and 3-132).

Step 6 Return again to Channels and select the Blue channel. This time, set the Cell Size of the Pointillize filter to 20. It appears to not make any difference which Channel carries which size, as long as the Cell Sizes vary for each (Figures 3-133 and 3-134).

Step 7 At the Channel window, select RGB to get back to a full color image, then reselect Layers (Figure 3-135).

Figure 3-131

Figure 3-132

Figure 3-133

Step 8 Duplicate the working layer (just for insurance). From the Filter Menu, select Artistic>Palette Knife. Use my settings (Stroke Size 12, Stroke Detail 3, and Softness 0) only

Figure 3-134 Figure 3-135

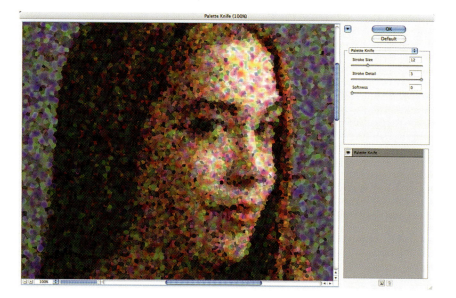

Figure 3-136

as a point of departure. I've found every image will require some experimentation. You can achieve a lesser effect by using Dry Brush instead of Palette Knife (Figure 3-136).

Step 9 Filter>Distort>Glass can change the flat strokes of the Palette Knife and make them look more like something painted with a rough brush. My settings; Distortion: 6, Smoothness: 4, Texture: Frosted, and Scaling: 50% seem to work well with a variety of images (Figure 1.137).

At this point, you can adjust the Opacity against the layer below, or Merge Down, or Deselect this layer and start over with the insurance layer. This example will be Merged, leaving me with just two layers.

Step 10 Duplicate the new working layer twice, then select the topmost layer (Figure 3-138).

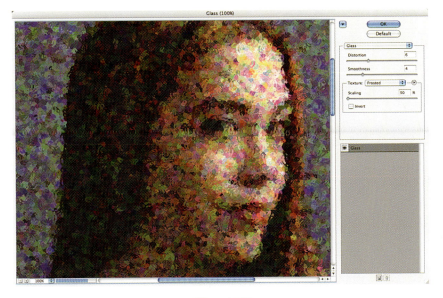

Figure 3-137

Figure 3-138

Step 11 A High Pass layer will increase the sharpness and contrast of the colors (see High Pass Sharpening elsewhere in the book for more details). Go to Filter>Other>High Pass and set a radius of ±80 pixels. The higher the number, the higher the contrast (Figure 3-139).

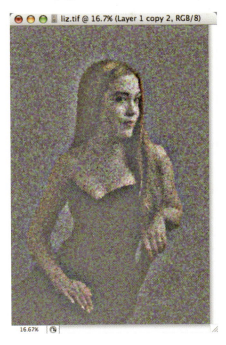

Figure 3-139

Step 12 Set the Blending Mode of the High Pass layer to Soft Light, then Merge Down (for a harder effect, set the Blending Mode to Overlay) (Figure 3-140).

Step 13 You may leave the image as is, and go on to the next step, or play with the Blending Modes to try some different effects. For instance, changing the Mode of the top layer to Overlay, Soft Light, Hard Light, or Vivid Light will increase the color contrast by varying degree, after which

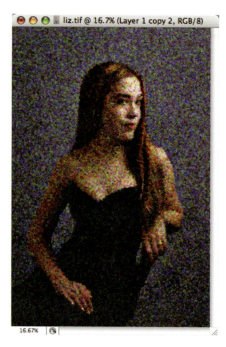

Figure 3-140

Figure 3-141

you can blend those top two layers using the Opacity slider. I used Soft Light for this image, at 74% Opacity (Figure 3-141).

Step 14 At the Toolbox, reselect Black as the Foreground Color and White as the Background Color by clicking on the small black/white icon below the color boxes (Figure 3-142).

Step 15 At the Layer window, duplicate the original, unaffected layer, and drag it to the top of the queue (Figure 3-143).

Step 16 Use Filter>Sketch> Photocopy to create an outline of the subject. Be careful to set Detail to minimize artifacts in the skin (I set it at 2) and Darkness to get some thick lines (I settled on 40) (Figure 3-144).

Figure 3-142

Figure 3-143

Step 17 Set the Blending Mode of the Photocopy layer to Multiply. The "fat" Photocopy lines bring some reality back to the image (Figure 3-145).

Step 17 is normally the final step in the Impressionism process but I can never resist the urge to play with Photoshop (neither should you) and frequently find new techniques to build on what I've done (Figure 3-146).

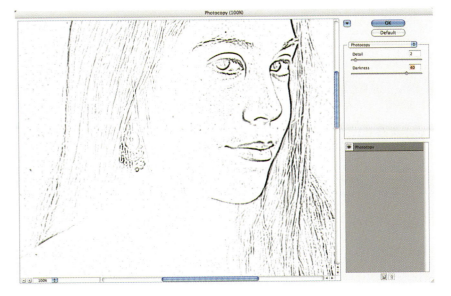

Figure 3-144

Try this for a beautiful retro look.

First, Flatten the image and do a Save As to the desktop or back to the file. Back up on the History palette and unflatten the layers. The Layers Palette will look like this (Figure 3-147).

Change the Blending Mode of the top layer, the Photocopy layer, to Color Dodge and the Blending Mode of the middle layer, Layer 1 Copy, to Soft Light (Figure 3-148).

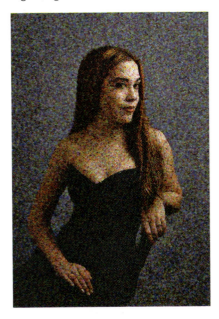

Figure 3-146

Figure 3-145

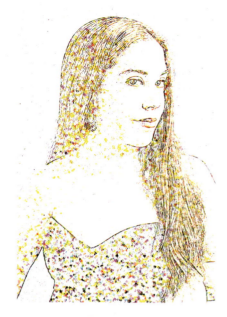

Figure 3-147

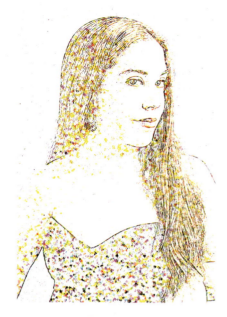

Figure 3-148

Scenic and travel images acquire a more artistic look when treated as impressionistic (Figures 3-149 and 3-150).

Figure 3-149

Figure 3-150

The Classic PinUp

Imitating the classic look of pinup art of the 1940s and 1950s, this illustrative technique can be applied to other photographic styles as well. The subjects of this art style were always drawn or painted with perfect skin and form; larger than life, so be sure to retouch any blemishes and remove any flaws in your photographic subjects before you apply any transformations. If a portion of the body, such as a line under an eye or the crease under an arm is not essential to the image, get rid of it. Also, be sure to brighten teeth and eyes:

Step 1 Duplicate the layer (Figure 3-151).

Step 2 Go to Filter>Blur>Smart Blur. Smart Blur blurs most everything but sharp lines (another reason to remove or soften unwanted body lines). Start with my settings as shown or experiment until you find a Radius/Threshold ratio you like more. Then, to further soften the chosen features, apply Smart Blur a *second* time (Figure 3-152).

Step 3 I noticed the top of the martini glass almost disappeared, so I created a duplicate layer, darkened it with Curves to bring it back then created a black Layer Mask. Using white as my Foreground Color, I painted through the black mask, at 20% Opacity, until it was as dark as I wished. It's

Figure 3-151

Figure 3-152

possible this will happen to bright details in your images, too, so look at each effect carefully and fix whatever is necessary. When done with this step, use Layers>Merge Down to combine the masked layer with the working layer (Figure 3-153).

Now that we can see how the Smart Blur filter changed the image, some additional retouching is necessary. Filter>Liquify is a misunderstood tool, commonly used to alter faces for comic relief. As a

Figure 3-153

retouching tool, it's extremely powerful, and can reshape entire areas, especially if the background is plain. I was bothered by how lumpy the vintage bathing suit got when the model, quite trim in real life, bent even a little bit.

Step 4 Use Filter>Liquify to push, slowly and gently, the bathing suit flat against her body. I'll also use it to smooth out the musculature of her left calf and right thigh. If you've not used the filter before, spend some time just playing with it before tackling a money job. A couple of small hits with the Clone tool complete the retouching (Figure 3-154).

Figure 3-154

Step 5 Dupe the working layer. Set the Blending Mode to Soft Light (Figure 3-155).

One could probably stop here. After all, the image has been retouched and looks very painterly. Contrast is up and the color is more intense. In fact, when you try this on your own image, make note of the way things look to this point so you can use the technique in the future. A few more steps will get you closer to an original paint or chalk look (Figure 3-156).

Step 6 Apply a texture to Layer 1 Copy by selecting Filter>Artistic>Underpainting. As always, my settings (Brush Size 25, Texture Coverage 21, 100 Scaling, and

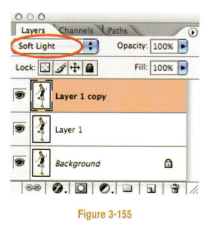

Figure 3-155

20 Relief) are merely guidelines, working to my satisfaction for this image. Your needs may be different, or you may like a different texture (Figure 3-157).

Step 7 Use Filter>Artistic>Rough Pastels to streak the colors of both the image and the Underpainting applied in the last step. Note that I've set a Stroke Length of "0" to keep the spread very short (Figure 3-158).

Step 8 The filter, Rough Pastels, will streak in one direction only, but the effect will be better if the effect seems to come from more than one direction. Select Image>Rotate Canvas>90 CW, then apply Rough Pastels again, without changing any settings (Figure 3-159).

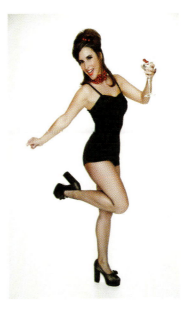

Figure 3-156

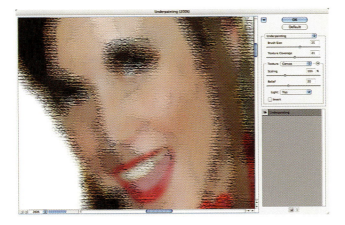

Figure 3-157

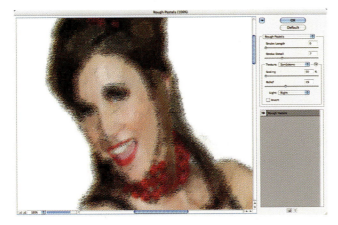

Figure 3-158

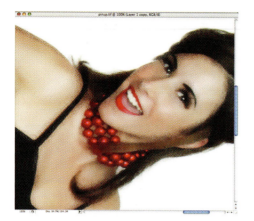
Figure 3-159

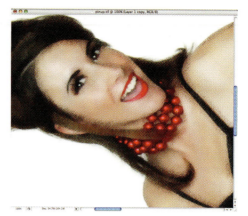
Figure 3-160

Step 9 Go back to Image>Rotate Canvas and select Flip Canvas Horizontal. Apply Rough Pastels again (Figure 3-160).

Step 10 Return the image to its normal orientation. Now apply Filter>Artistic>Paint Daubs. Begin your trials with my settings of Brush Size 23 and Sharpness 10, then play around and find your own (Figure 3-161).

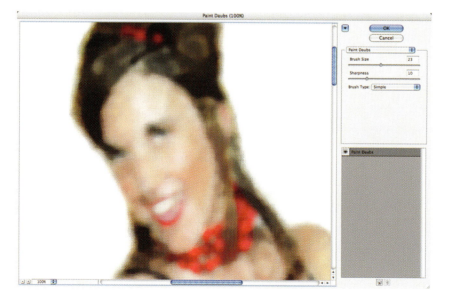
Figure 3-161

Step 11 Layer>Flatten Image to merge all layers. Retouch any oddball artifacts that may have occurred during the application of all these effects, then Save (Figures 3-162 and 3-163).

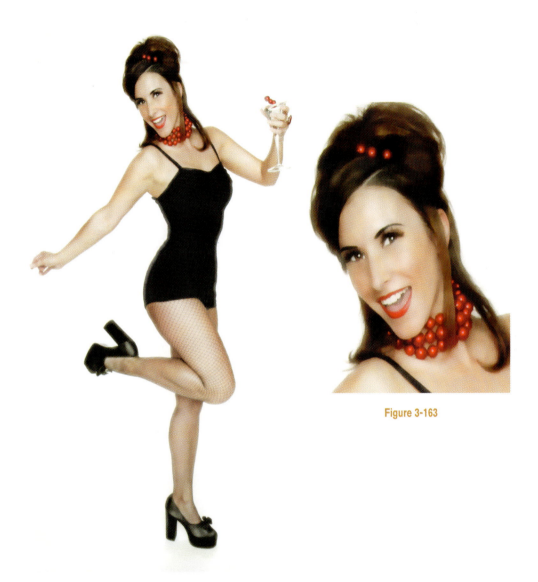

Figure 3-163

Figure 3-162

Oil Chalk

This is a beautiful technique that embodies the best of smooth, highly detailed oils and the texture of lightly applied chalk. You may find this useful for a variety of imagery, especially traditional, editorial, or glamour portraiture.

The effect of the texture is quite subtle, so practice until you know how thickly to apply it based on the size of the final image. Personally, I think it works best on large prints but I leave you to be the judge of that.

Do all retouching first. Be sure to get skin as perfect as possible:

Step 1 Open the image and duplicate the layer (Figure 3-164).

Step 2 Go to Filter>Blur>Smart Blur. This trick requires more than usual, and I've set the Radius at 20, the Threshold as close to 11 as the program will allow, Quality to Low. The Blending Mode is Normal (Figure 3-165).

Step 3 Dupe the active layer (Figure 3-166).

Step 4 Use Filter>Distort>Diffuse Glow to add a little more highlight than what you would normally see in a photograph. Remember that the Diffuse Glow filter gets its color from the Background color showing in the Toolbox. I did

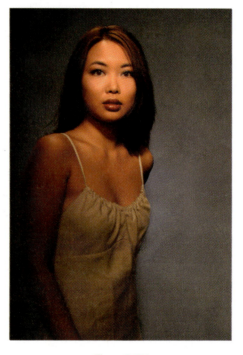

Figure 3-164

Figure 3-165

Figure 3-166

Figure 3-167

not use any Graininess, and set the Glow Amount to 5 and the Clear Amount to 19. You may like a different combination (Figure 3-167).

Step 5 This next step is also one with which you should experiment, for it will determine how much texture is visible at a given print size. Filter>Artistic>Rough Pastels, when the Stroke Length is 6, Stroke Detail is 6, Texture is Sandstone (my favorite of the group), Scaling at 100, and Relief at 16, will produce the same result as my sample, but it will not be as much as you see here because of the coming Blending Mode change in Step 7 (Figure 3-168).

Figure 3-168

Figure 3-169

Figure 3-170

Step 6 Image>Adjustments>Desaturate will remove all color from the image (Figure 3-169).

Step 7 Change the Blending Mode of the active layer to Soft Light (Figure 3-170).

Step 8 A detail from the final image reveals how gorgeous this technique is (Figures 3-171 and 3-172).

This technique will add contrast. If it's too much for you, try a Brightness/Contrast Adjustment Layer from the Layers Palette.

When your image has a pure white background, try sampling a bright skin highlight detail for the Background color in Step 4. The Diffuse Glow filter will add this color to the pure white as well, giving the image background some detail.

Figure 3-171

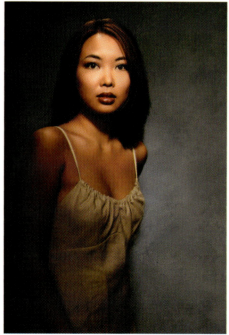

Figure 3-172

Index